KENT IN PHOTOGRAPHS

BRYAN PHILLIPS

AMBERLEY

First published 2019

Amberley Publishing
The Hill, Stroud
Gloucestershire, GL5 4EP

www.amberley-books.com

ISBN 978 1 4456 8666 0 (print)
ISBN 978 1 4456 8667 7 (ebook)

British Library Cataloguing in Publication Data.
A catalogue record for this book is available from the British Library.

Typesetting by Aura Technology and Software Services, India.
Printed in the UK.

ACKNOWLEDGEMENTS

I am indebted to a number of people in the support and capture of many of the images in this book. My wife, Avril, is my inspiration, my guide and my gear-carrying companion for many of my journeys and treks through the county and beyond. She is the steadfast deliverer of lens and camera changes as I see and try to capture the time-bound images in front of me, always looking for a perfect shot. My eldest daughter, Lorraine (also a photographer), has been a stand-in when those early-morning shots demand waking at 3 or 4 a.m. to travel to sites in the dark to be able to capture those unique impressions of sunrise.

Cheryl is my youngest and she keeps me in touch with the new technology and media developments so that I can successfully keep in touch with those who have followed my journey as Lightlog – with an aim to capture and replicate the light show that I see as I travel and note locations for future potential work.

Thanks are due to Amberley Publishing for noticing my work. Nick Grant in particular was instrumental in getting things in place. Also all the support I have received from friends, family and colleagues who have encouraged me to expand my reach with this book.

ABOUT THE PHOTOGRAPHER

Bryan Phillips is a proud Black Country man, growing up in the middle of the country among the steel-making industries the area is famed for. He has been the subject of a number of events showcasing his work, expressing his images through a variety of different media and formats.

'It's all about the light' is a significant phrase used by Bryan, relating to the natural light element that is so important in building his images for reproduction. This knowledge brings the realisation that each location has a series of potential results depending on the immediate light conditions and so a return to the same location builds a library of images that can look quite different. Being an 'early bird', sunrise is an important time for him and you will see the results of some of these in the following pages.

In his daily life, Bryan is a marketing and sales professional in the technology industry and this is where his association with Kent began. Bryan always has a camera at the ready. Therefore, travelling through and around the county (as well as the world), there are often opportunistic captures that await the ever-ready photographer. Of course there are those that were missed when time pressures or mode of transport meant that a halt was not possible, even if only for a moment.

Bryan has successfully presented images for the BBC, a US backpackers' guide and various projects around the country, but he still enjoys the buzz of a gallery show where visitors often remark on the detail found in the canvases and prints on display.

'Photography is my escape, my safe place, my creative release and I hope that you will be able to see some of that as you look through the images and notes in this book. I have been involved in photography from an early age, growing up with a Kodak Brownie bellows camera and developing my own images either in the loft or darkroom-converted bathroom. Modern equipment is much more versatile and allows high-quality images to be more frequently captured.'

The images in this book have been captured using a variety of cameras, lenses and attachments. Some of these are below:

Cameras: Nikon D850/Nikon D800/Nikon D810/Nikon D700/Nikon D300
Lenses: Nikkor AF-S 24–120mm/Nikkor AF-S 16–35mm/Nikkor AF-S 70–300mm/Nikkor 200–500mm
Accessories: Giottos MML3290B Monopod/Tiffen Filters

INTRODUCTION

Kent is such a diverse county, but full of captivating images from coast to country and beyond. It is known as the Garden of England and you will see images from this aspect, including both crops and locations that echo the essence of the county.

Magical and historic references abound, with ancient sites, defences and natural phenomenon giving a breadth of fascination among the wide number of influences around the area. In researching this book I came across a historic site older than Stonehenge in the north of the county. There are also undefeated castles, remnants of war, untouched natural beauty and ingenuity among its jewels. Roman influence is visible from the size and grandeur of Richborough Fort, one of the first Roman bases in England, to tantalising locations such as Reculver on the north Kent coast. Road tracks, ancient and modern, show their heritage with strong influences still in full view.

Moving into the core of Kent, nature and history combine to give the visitor a look back in time. Along the way, you may well trip over something unusual or even unique, ranging from windmills with sweeps rather than sails to pub games like Bat and Trap, an old English game still played in the county.

Finally, the vast 350-mile coast of Kent brings astonishing views, beauty and historic references. The white cliffs are synonymous with Dover and England but stretch far beyond the busy port, and have views across to our French neighbours. But I fear that I am keeping you from the true purpose of this book: to give an insight into the fascinating county of Kent.

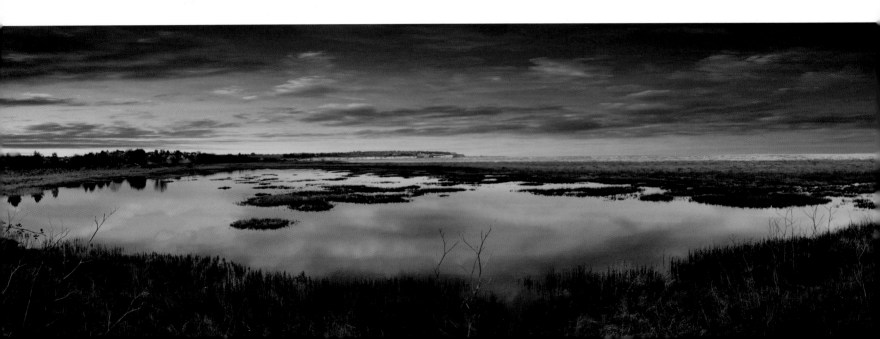

RIVER AND COAST

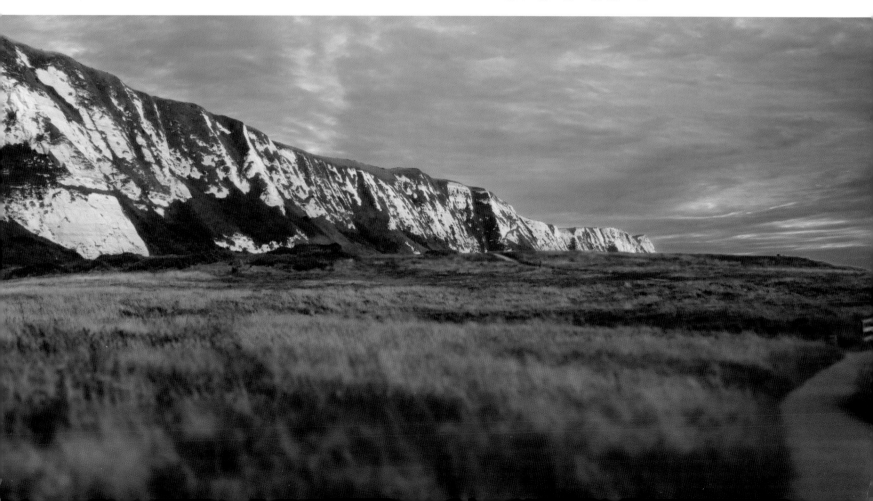

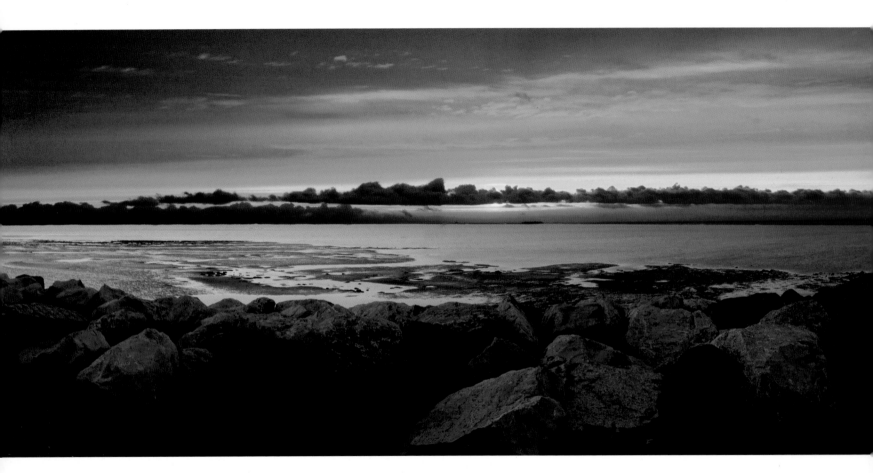

Rocks in the bay, Herne Bay coast

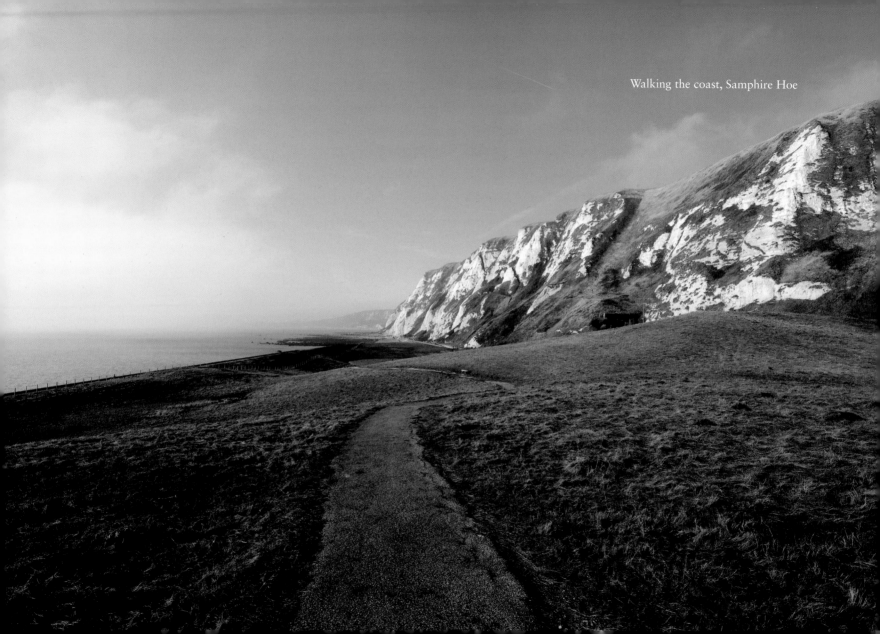

Walking the coast, Samphire Hoe

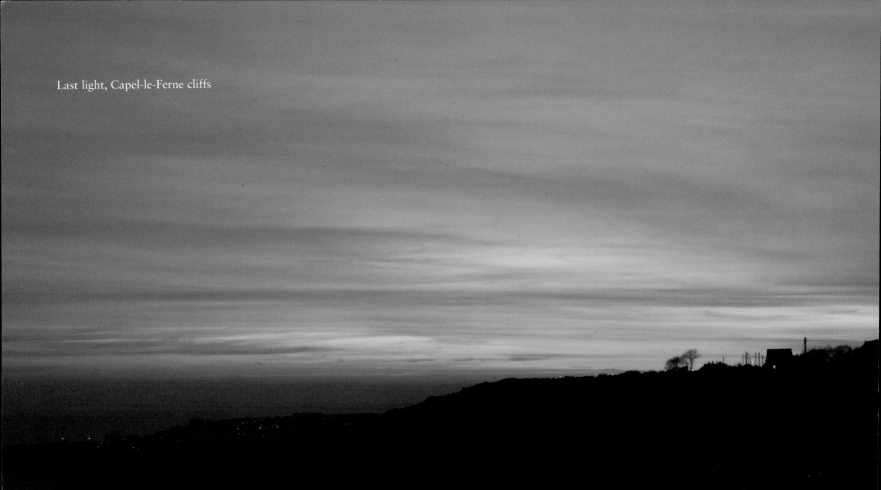

Last light, Capel-le-Ferne cliffs

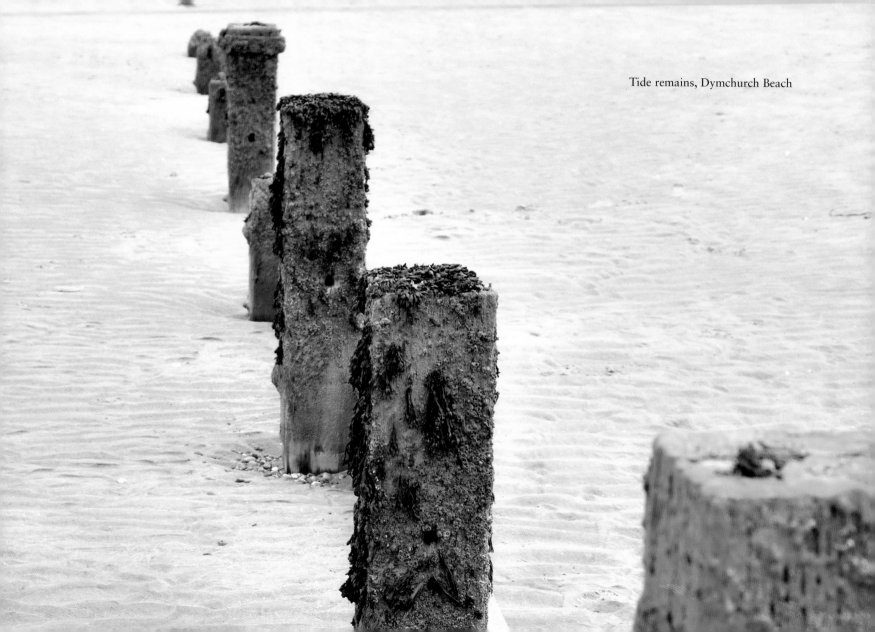

Tide remains, Dymchurch Beach

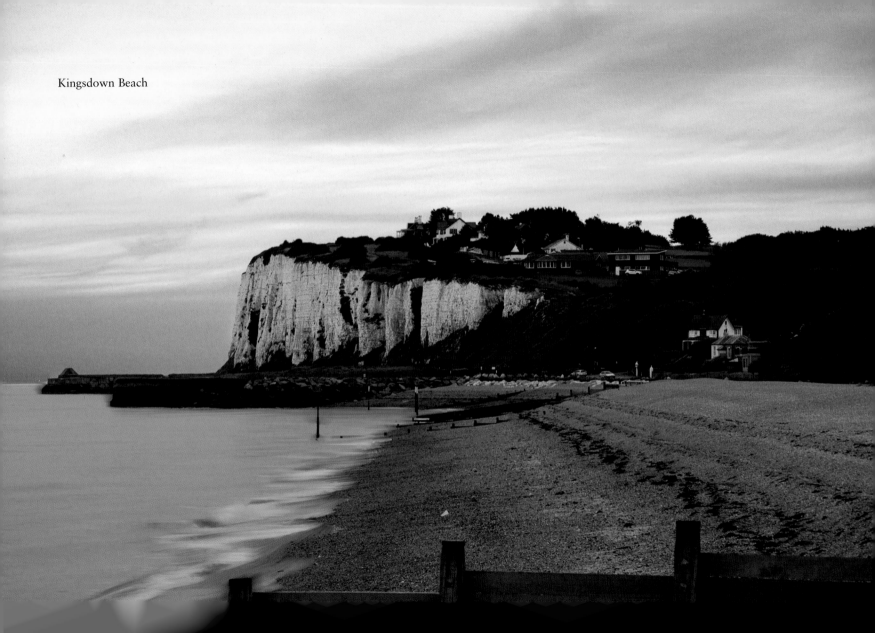

Kingsdown Beach

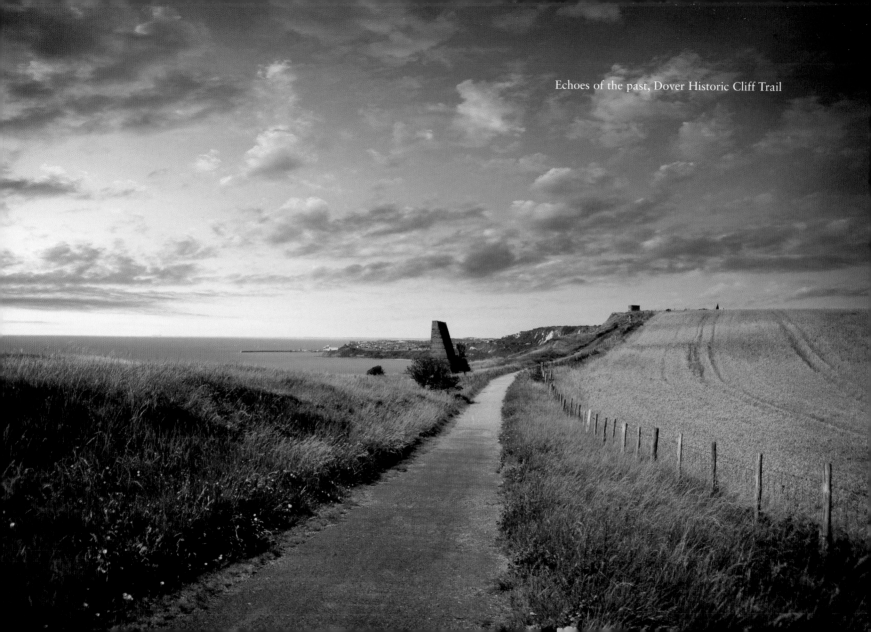

Echoes of the past, Dover Historic Cliff Trail

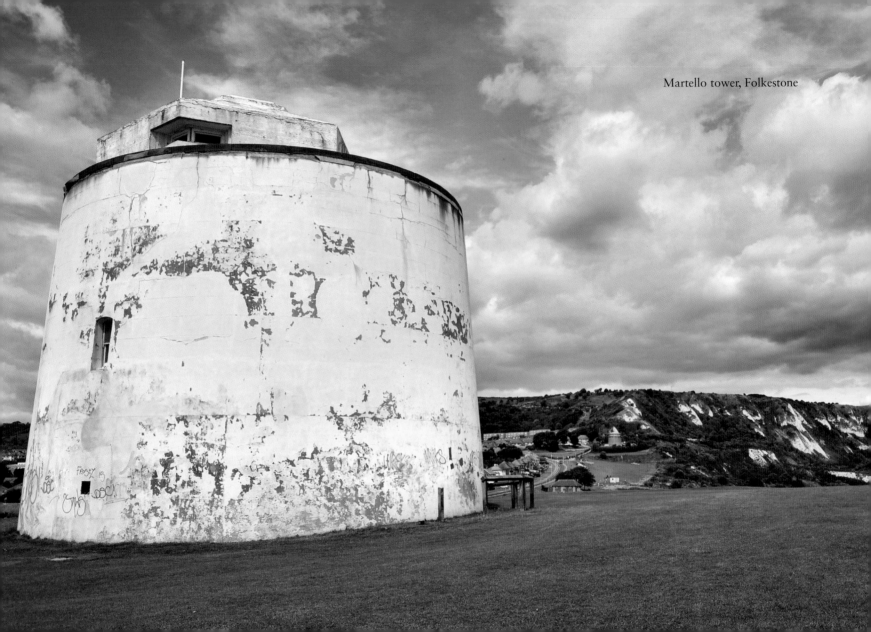

Martello tower, Folkestone

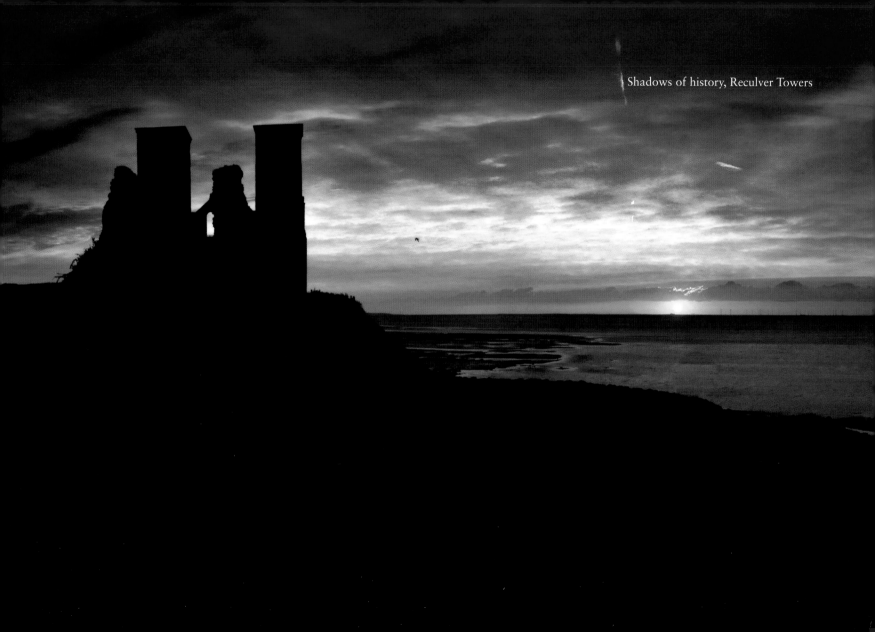

Shadows of history, Reculver Towers

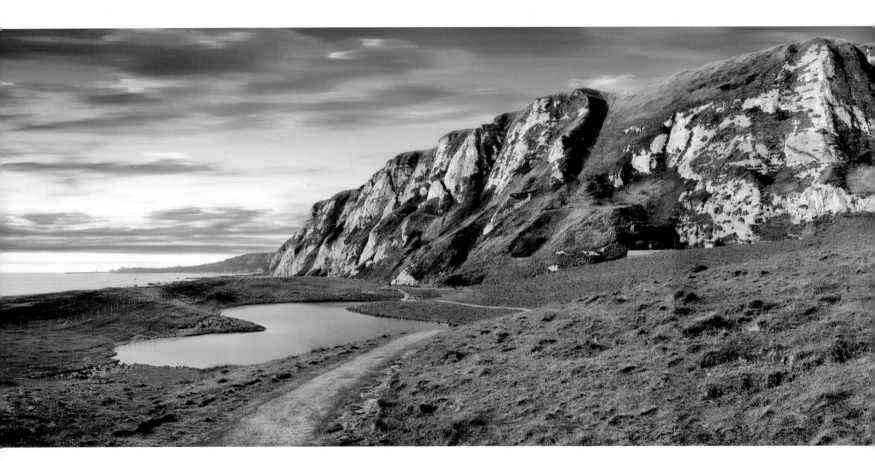

Seaside view, Samphire Hoe

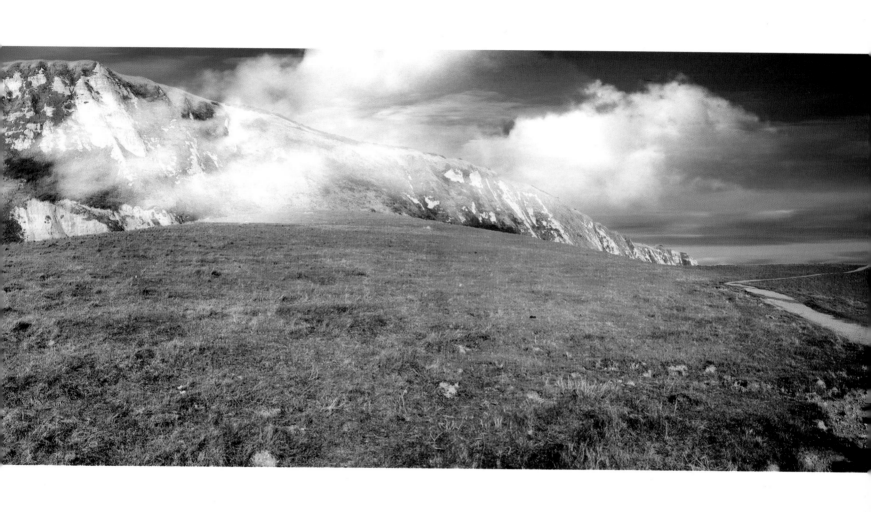

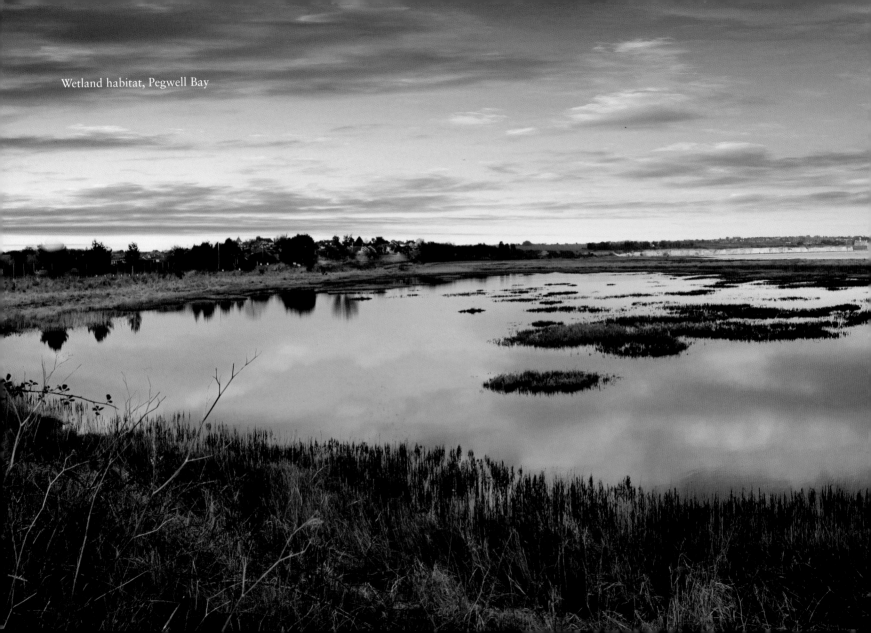

Wetland habitat, Pegwell Bay

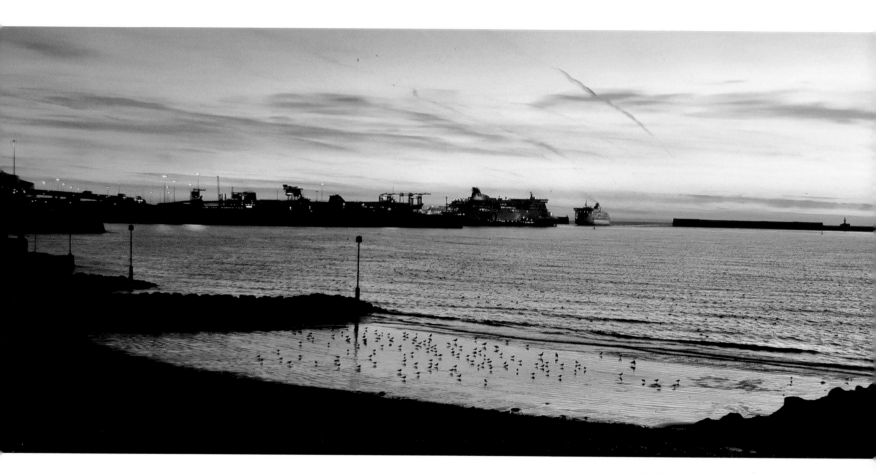

Early manoeuvres, Port of Dover

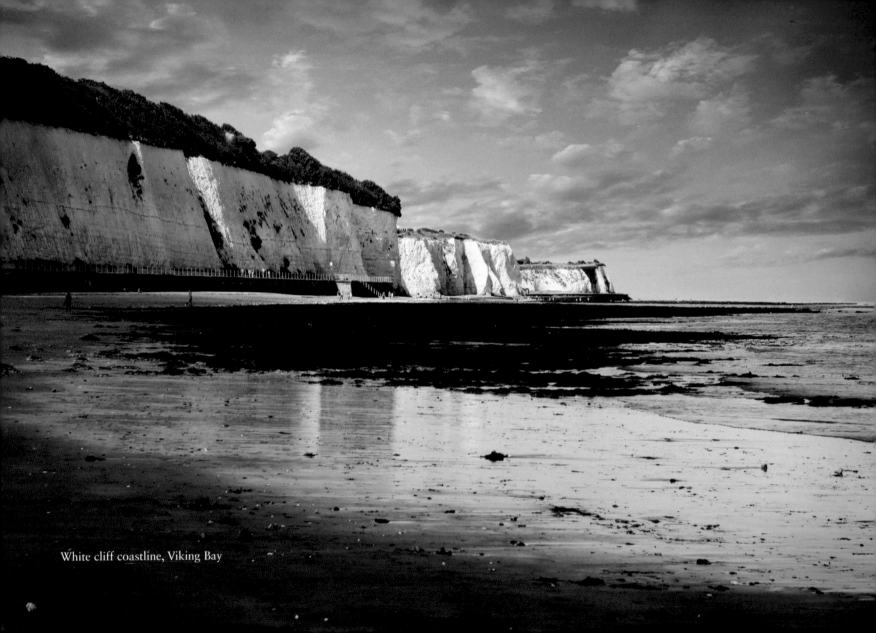

White cliff coastline, Viking Bay

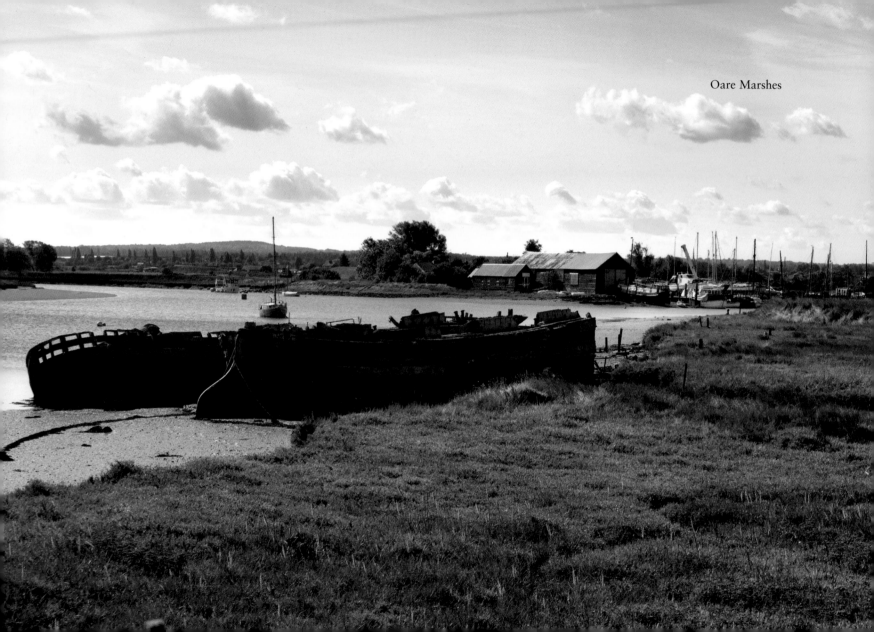

Oare Marshes

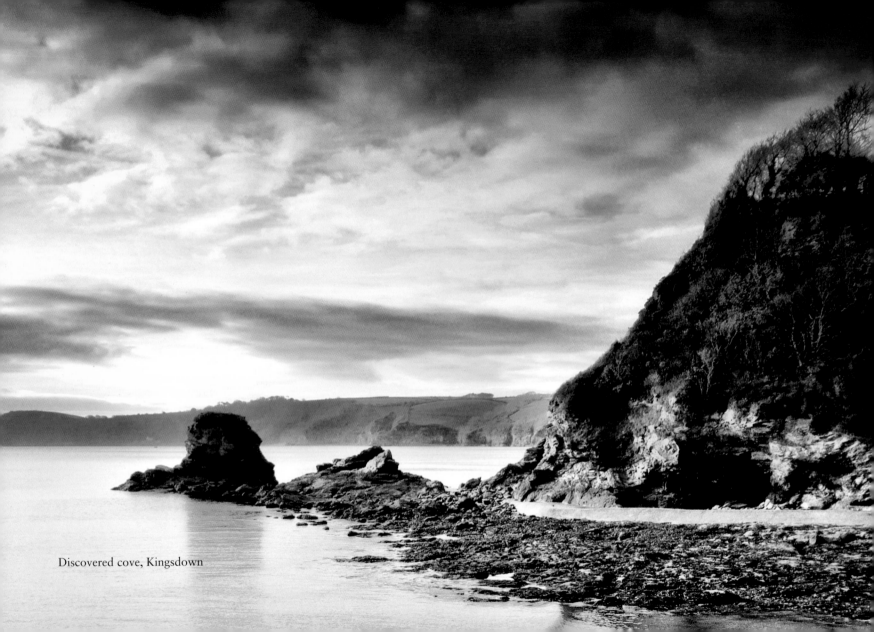

Discovered cove, Kingsdown

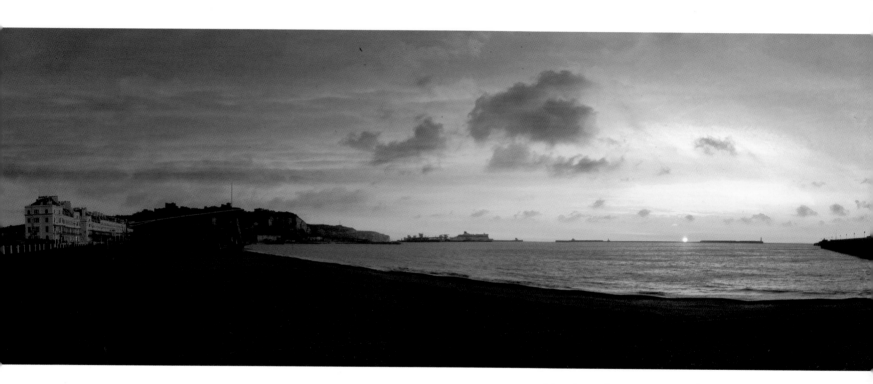

Morning welcome, Dover Harbour and seafront

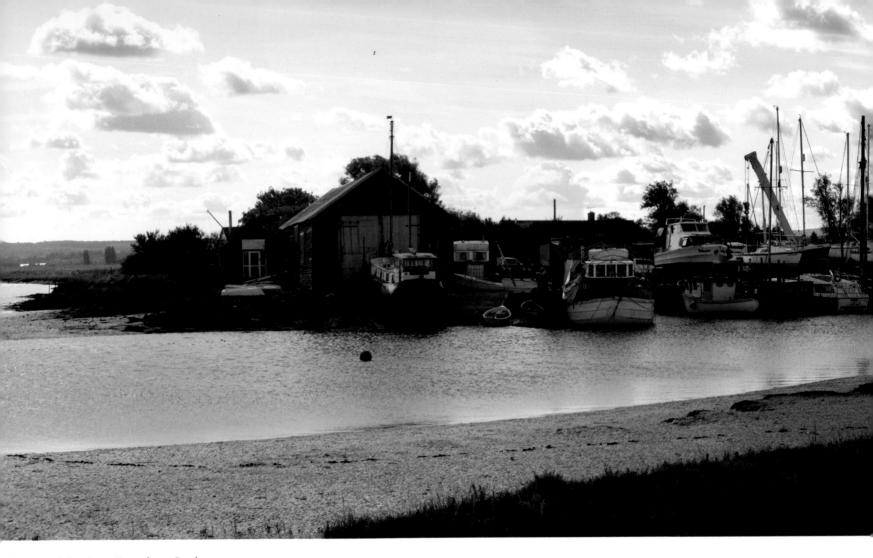

Moorings, Faversham Creek

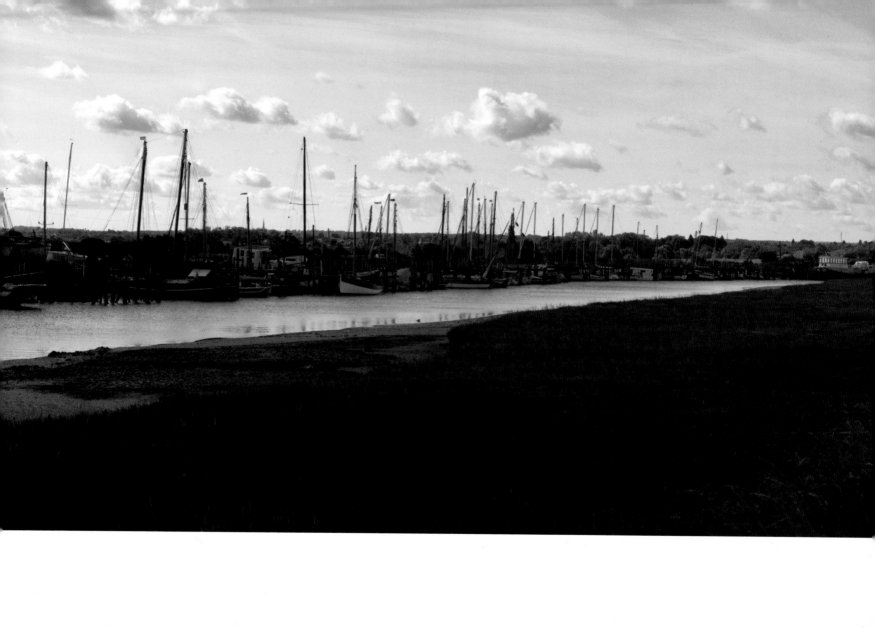

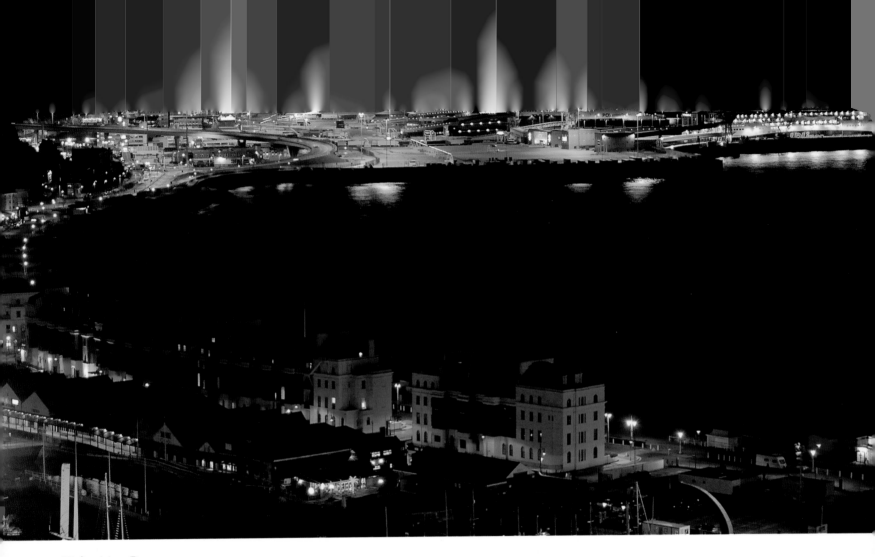

Night vision, Dover

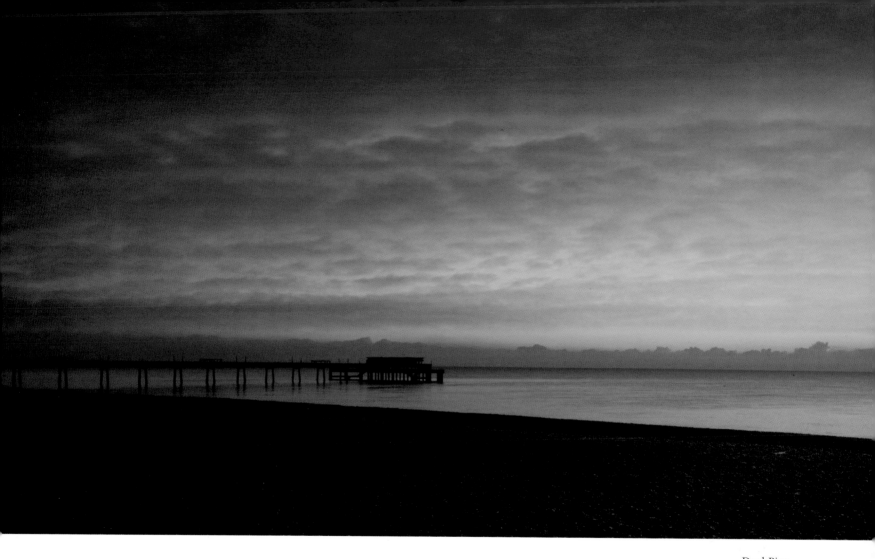

Deal Pier

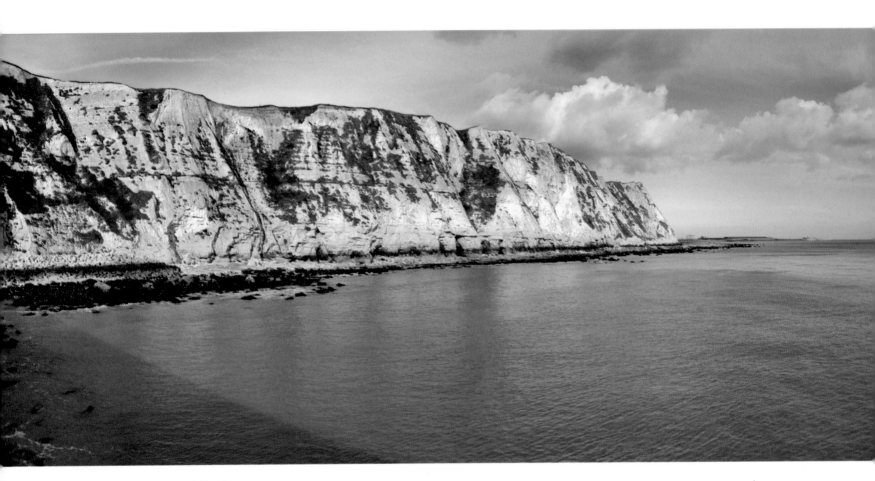

Edge of the map, White Cliffs of Dover

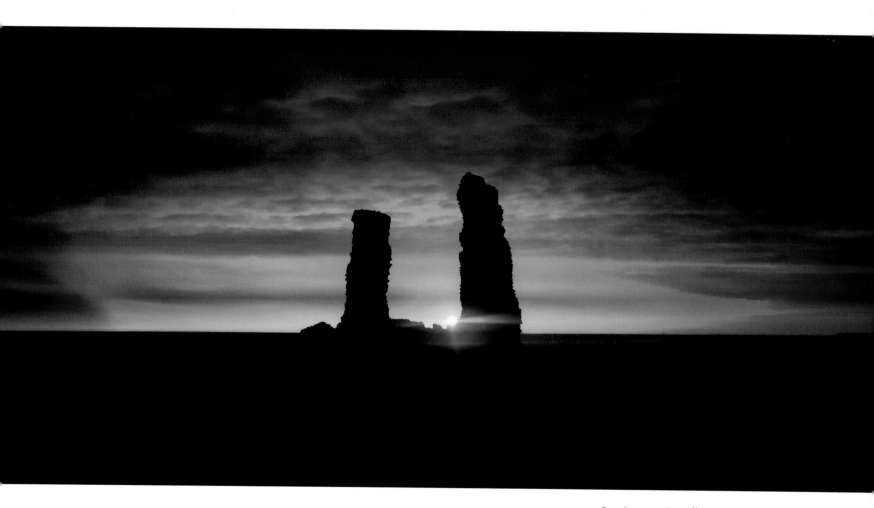

Sunrise over Regulbium's Roman fort

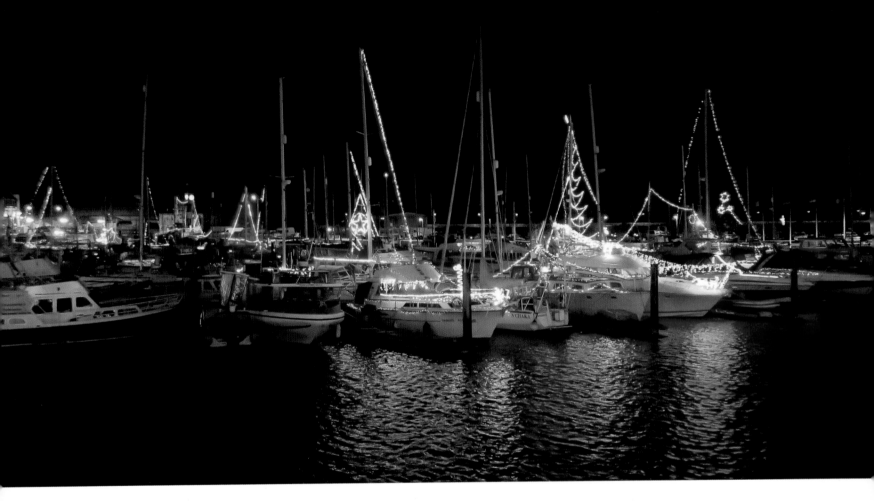

Royal Harbour, Ramsgate

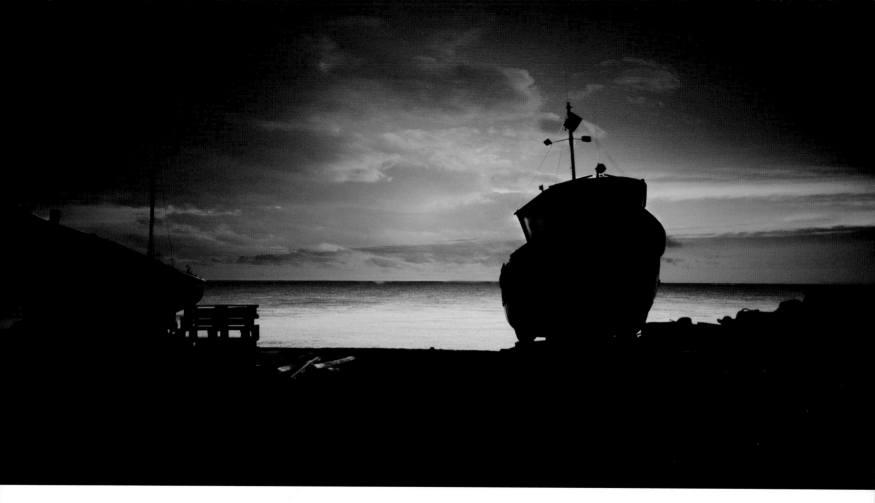

Fisherman's rest, Deal Beach

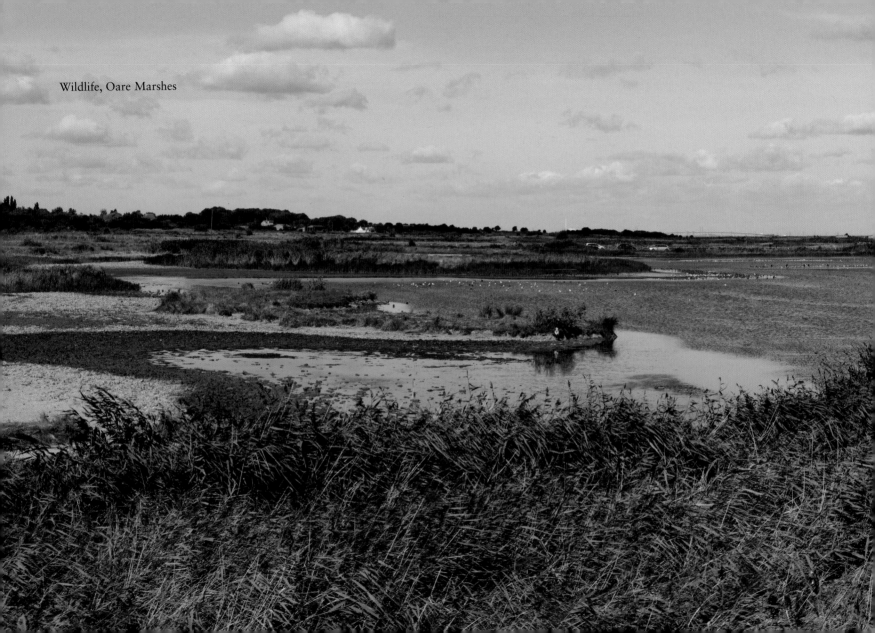

Wildlife, Oare Marshes

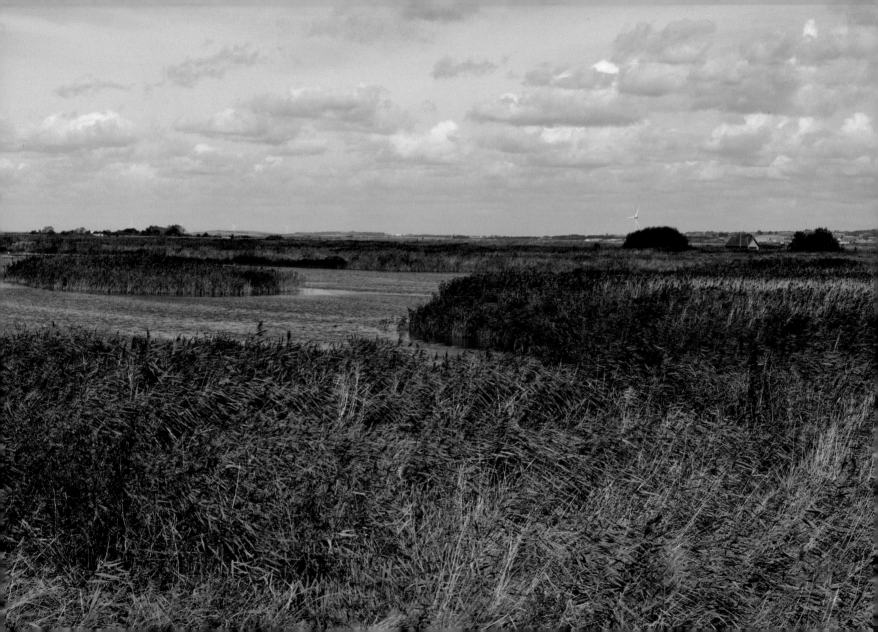

TOWN AND COUNTRY

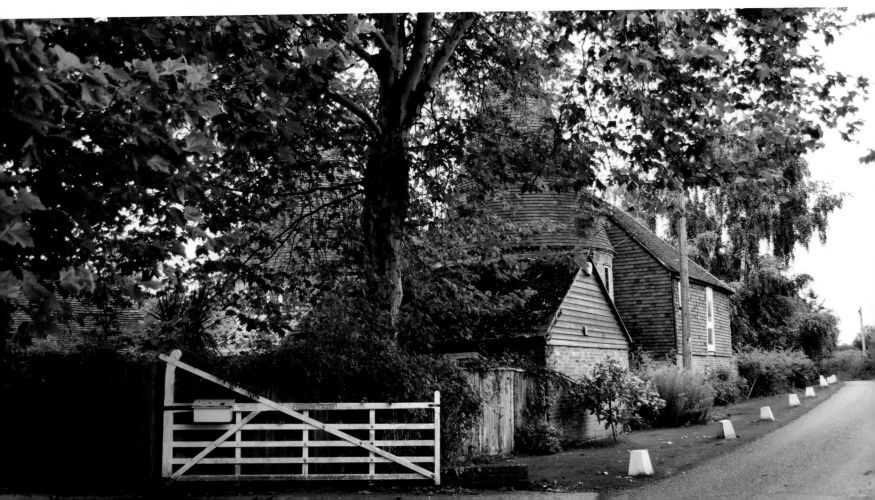

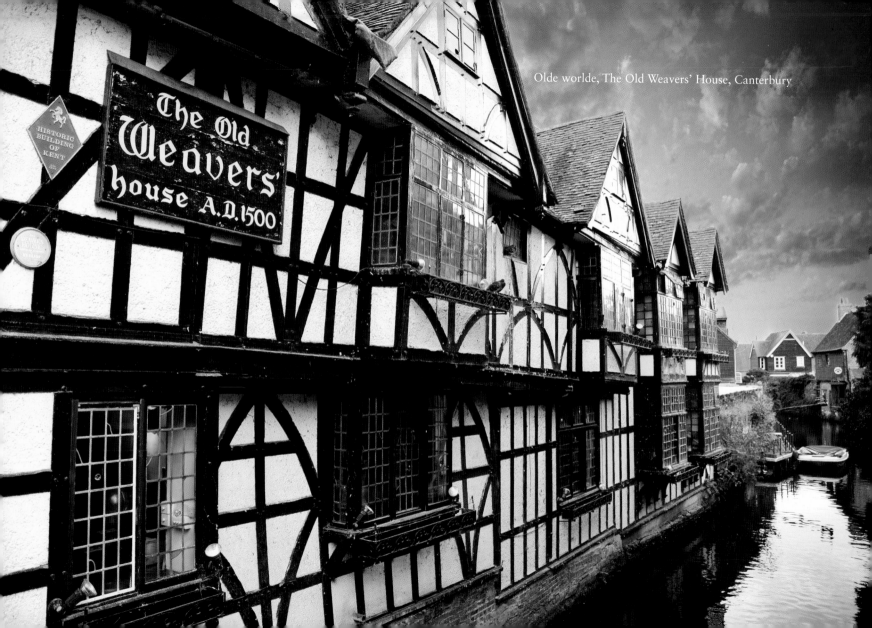

Olde worlde, The Old Weavers' House, Canterbury

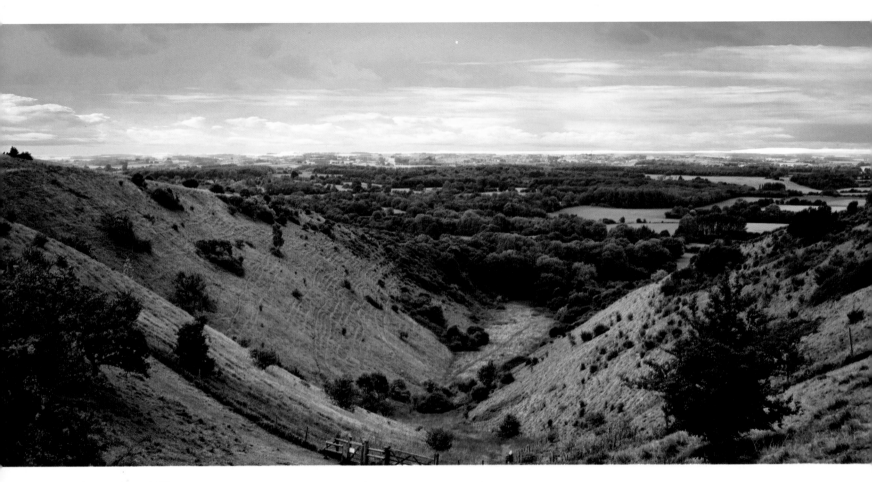

Devil's Punchbowl, Wye

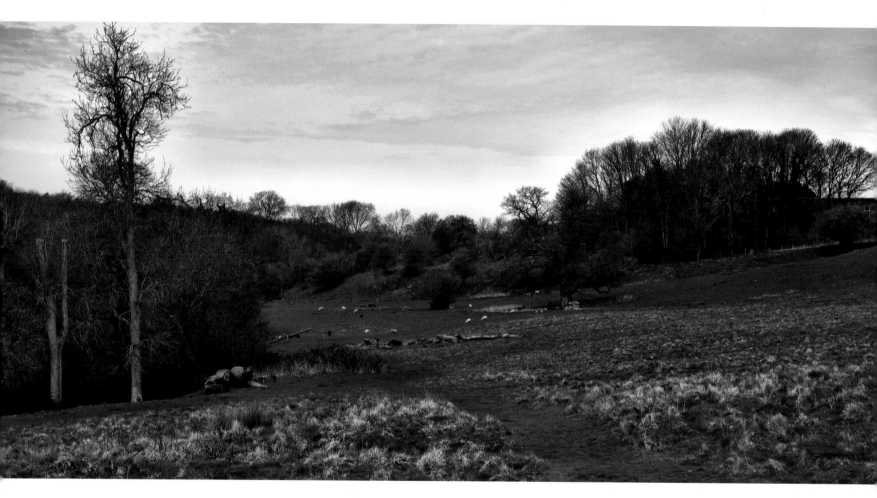

Brockhill Country Park

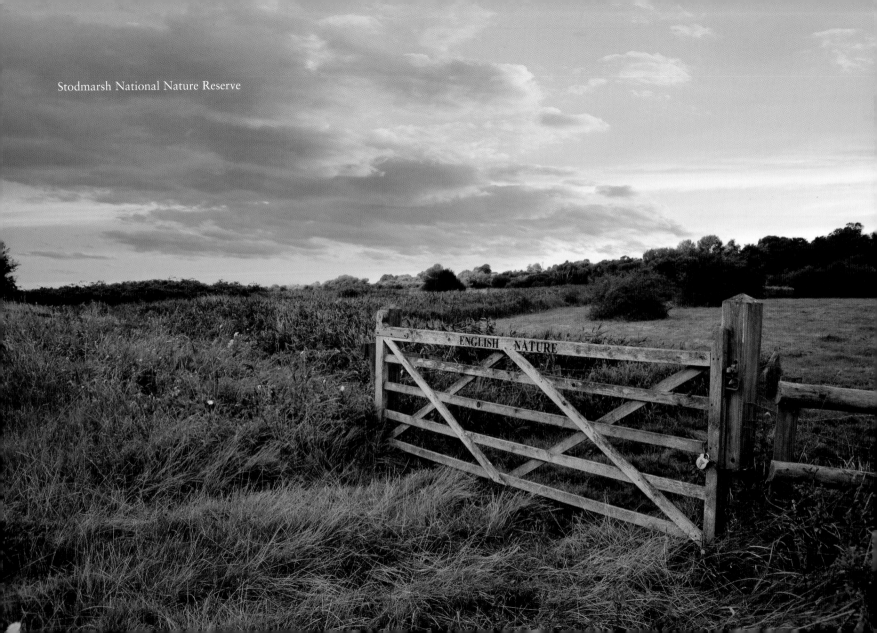

Stodmarsh National Nature Reserve

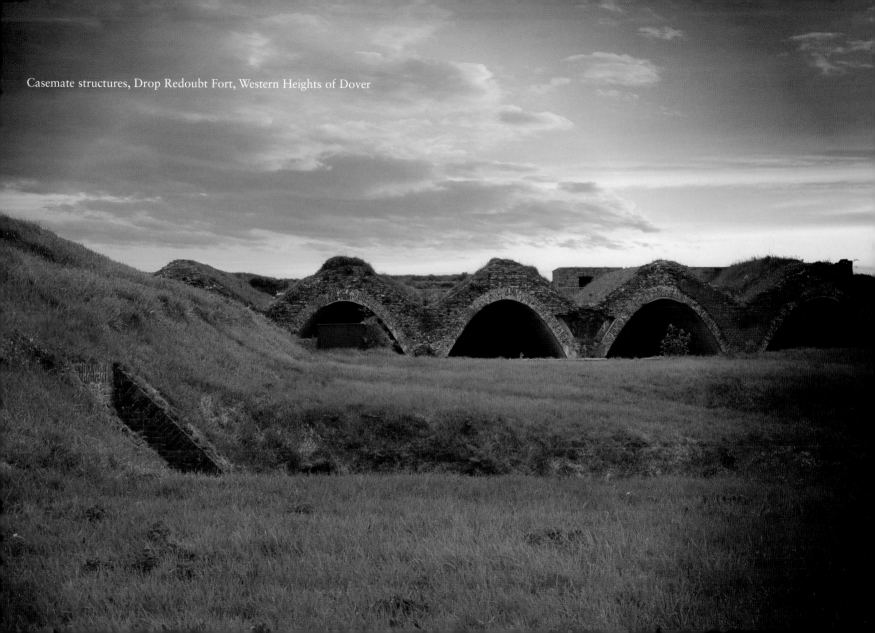
Casemate structures, Drop Redoubt Fort, Western Heights of Dover

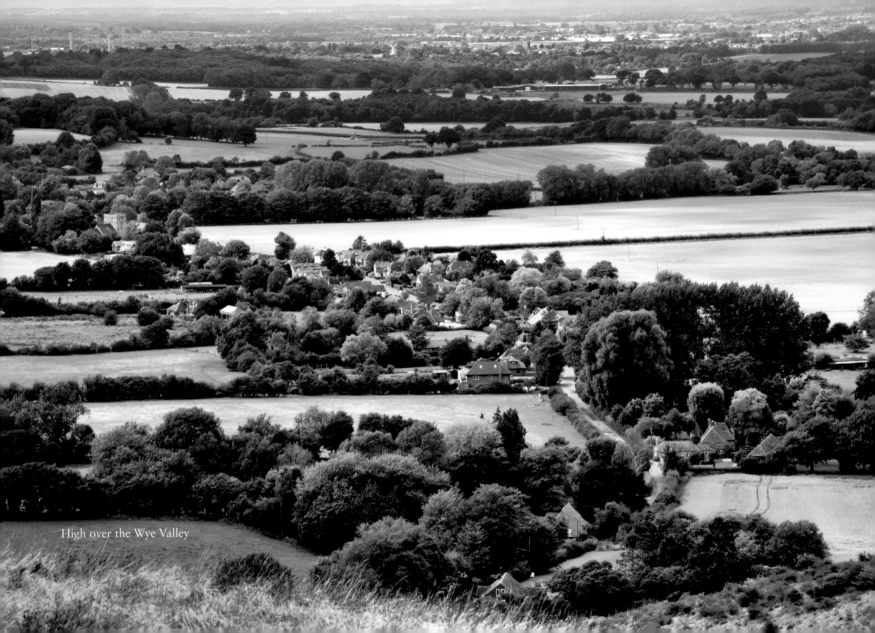

High over the Wye Valley

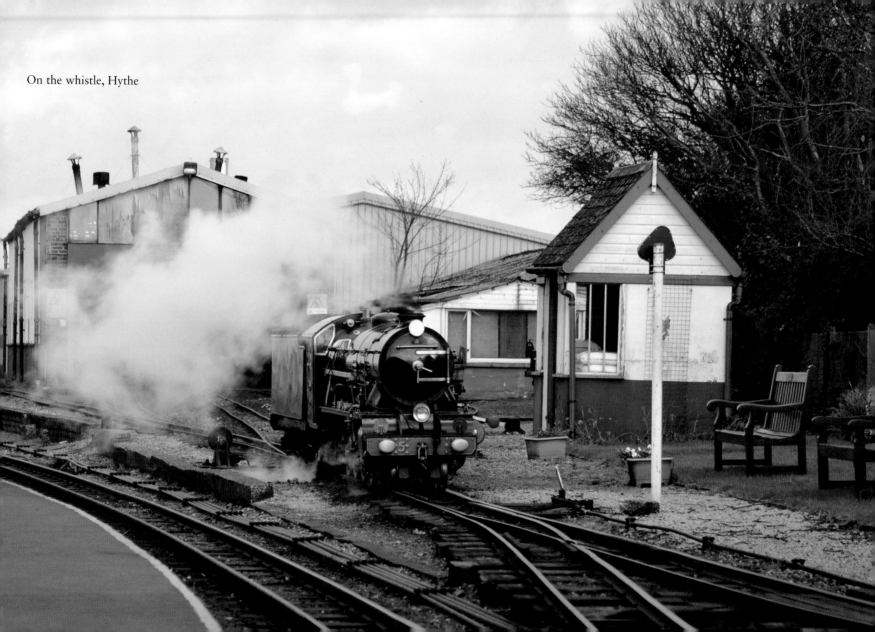

On the whistle, Hythe

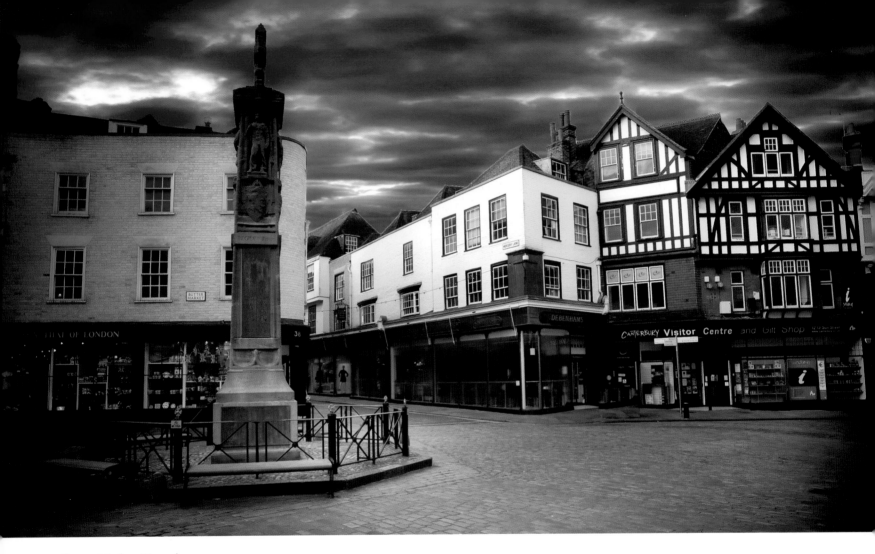

Butter Market, Canterbury

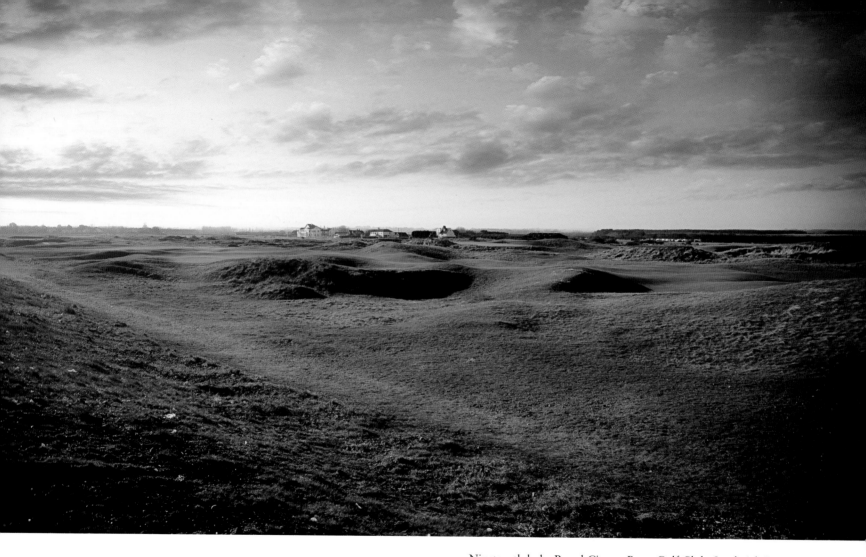

Nineteenth hole, Royal Cinque Ports Golf Club, Sandwich Bay

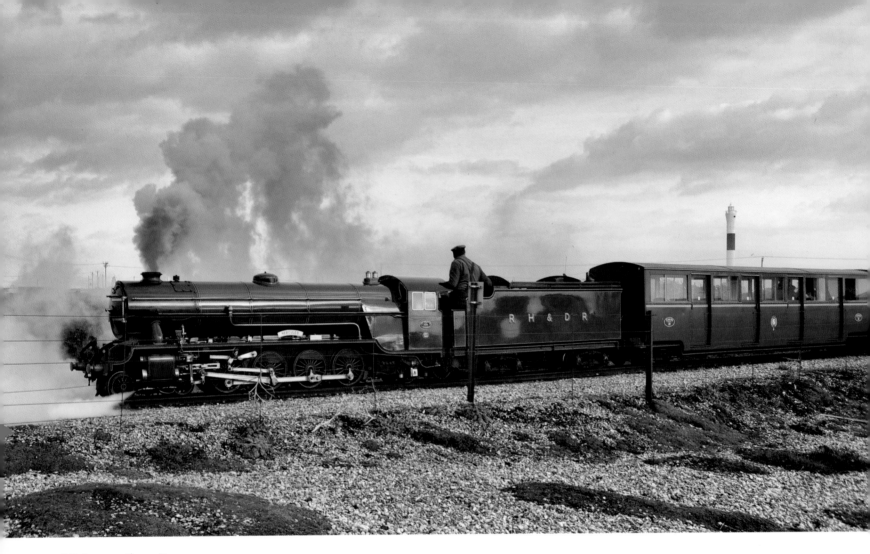

Miniature railway, Dungeness

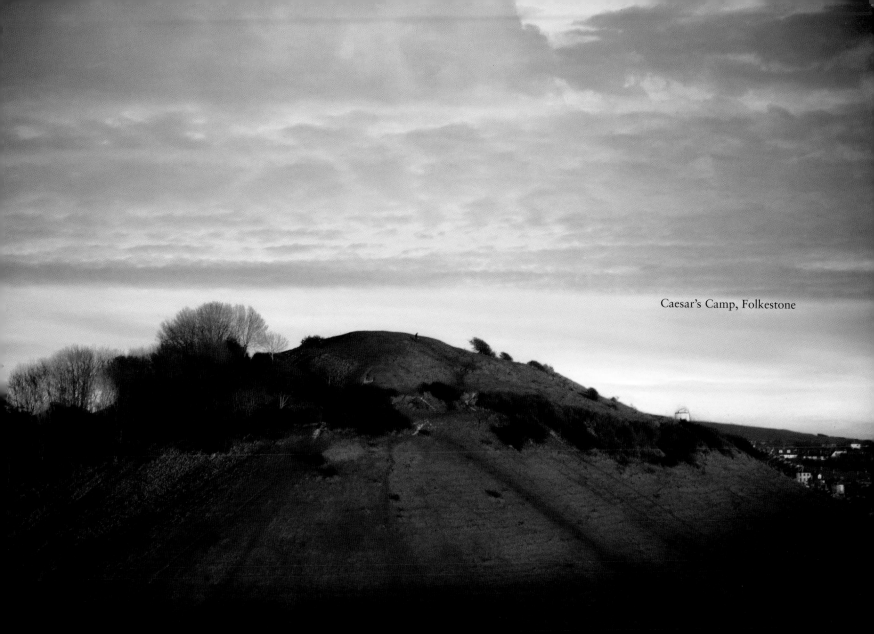

Caesar's Camp, Folkestone

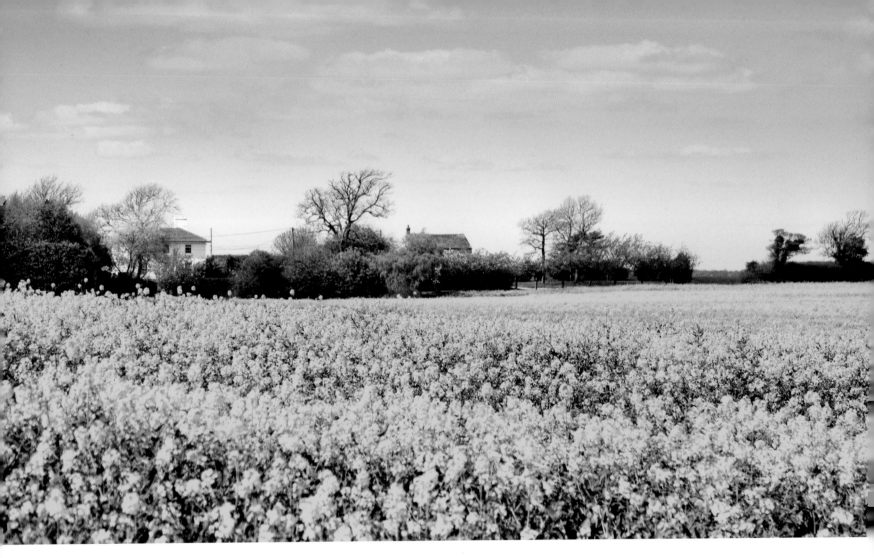

Great Cauldham Farm, Folkestone

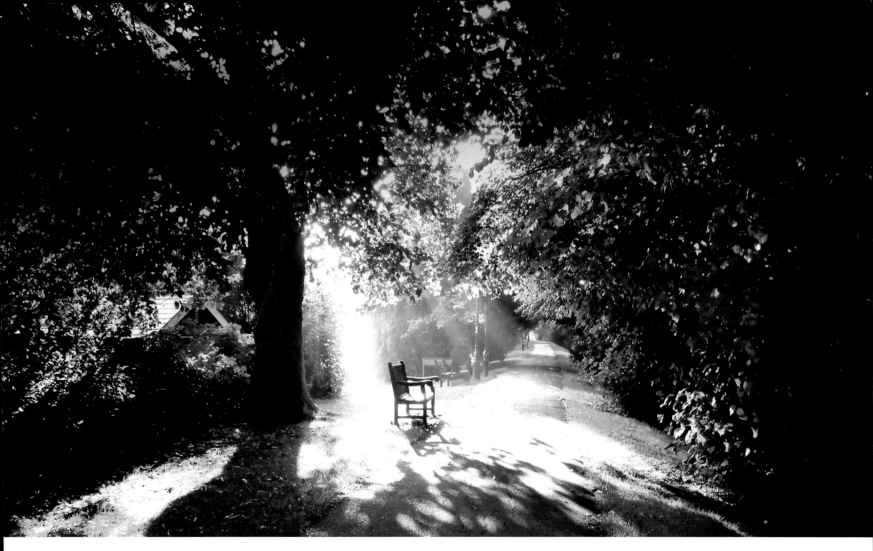

Shine a light, The Butts, Sandwich

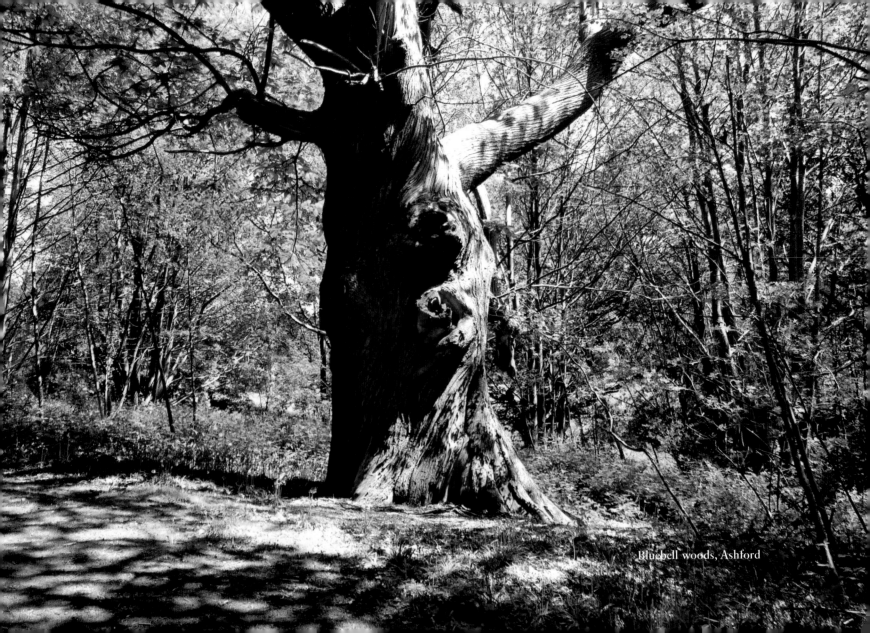

Bluebell woods, Ashford

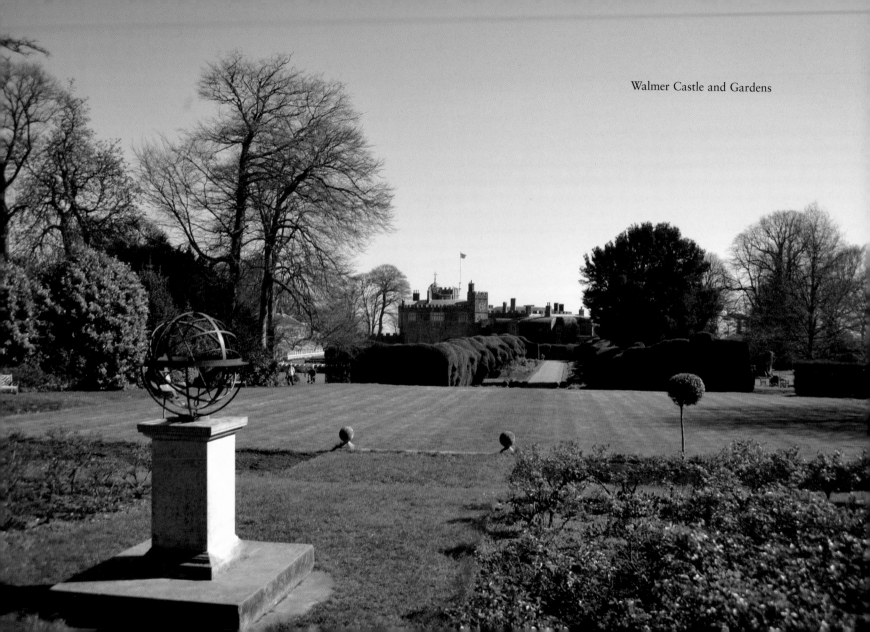

Walmer Castle and Gardens

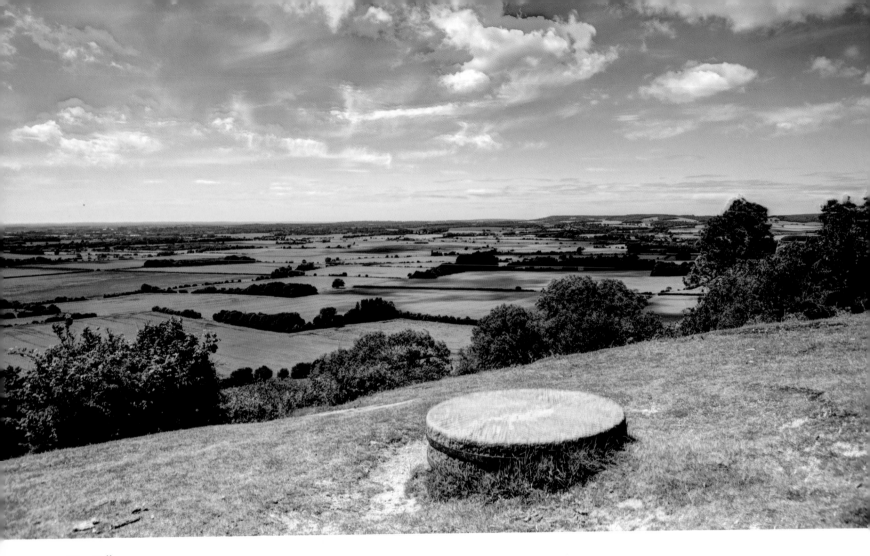

Wye Valley

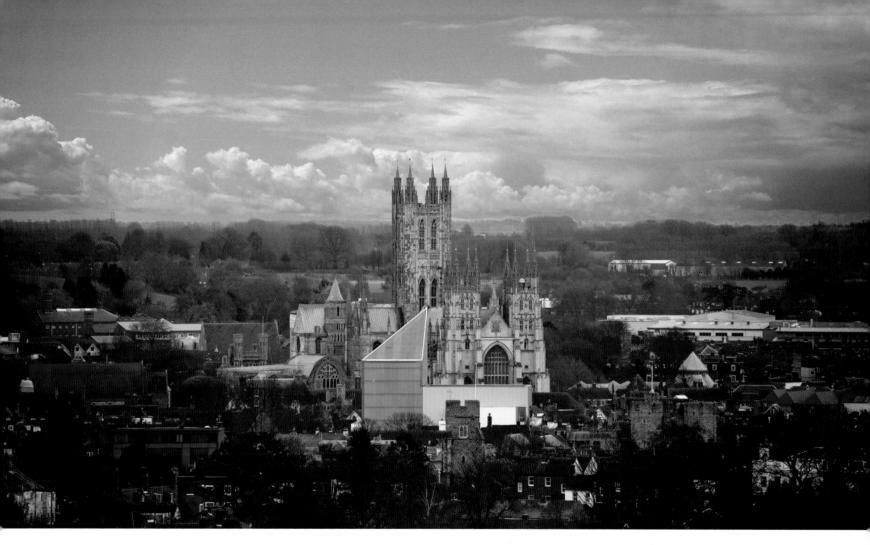

Canterbury Cathedral

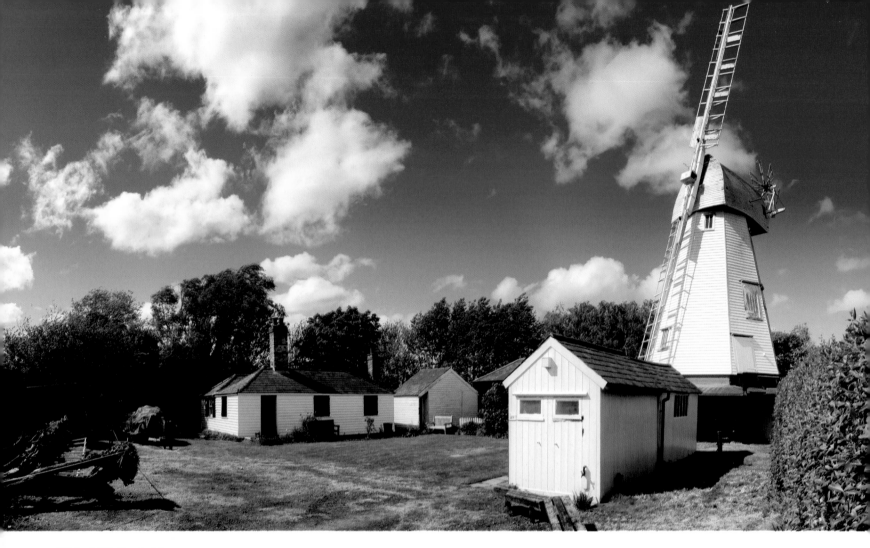

White Mill, Sandwich

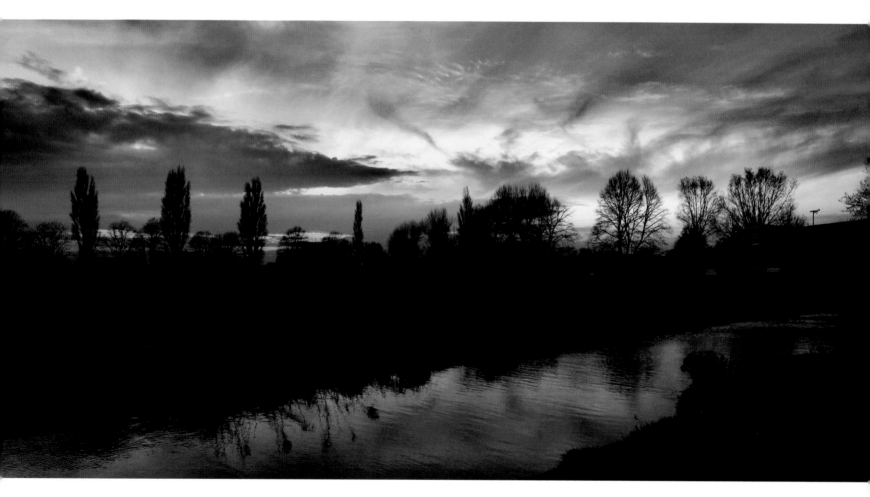

Sandwich Town Cricket Club

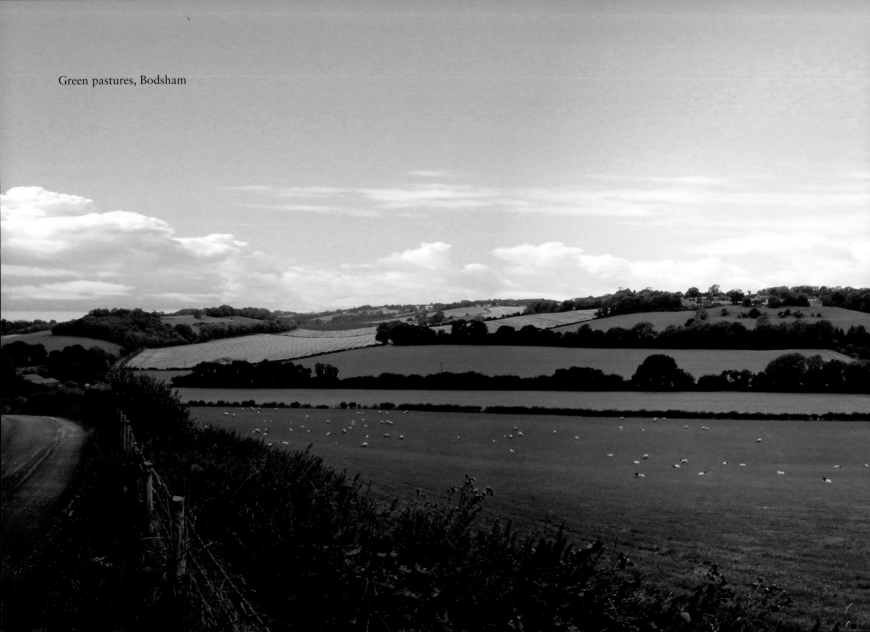

Green pastures, Bodsham

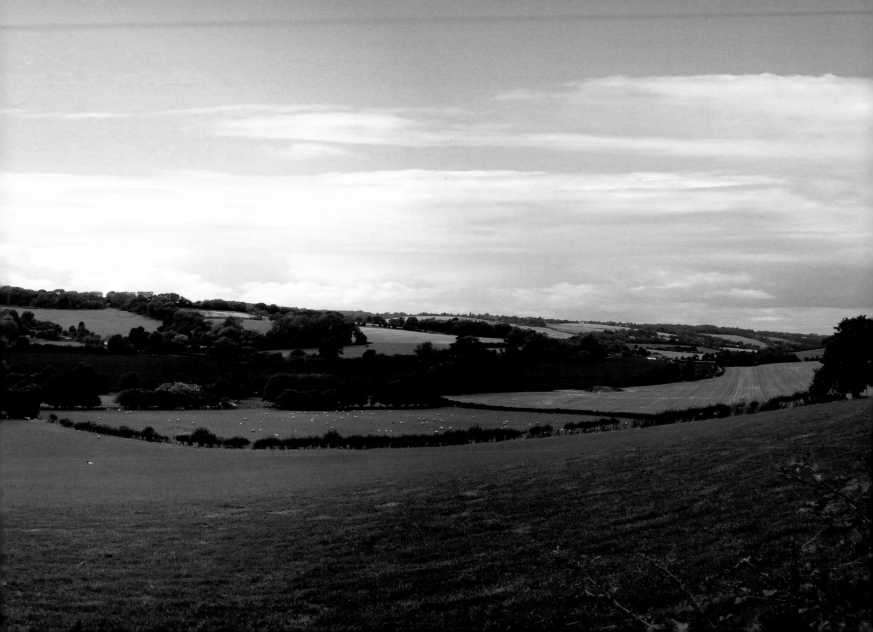

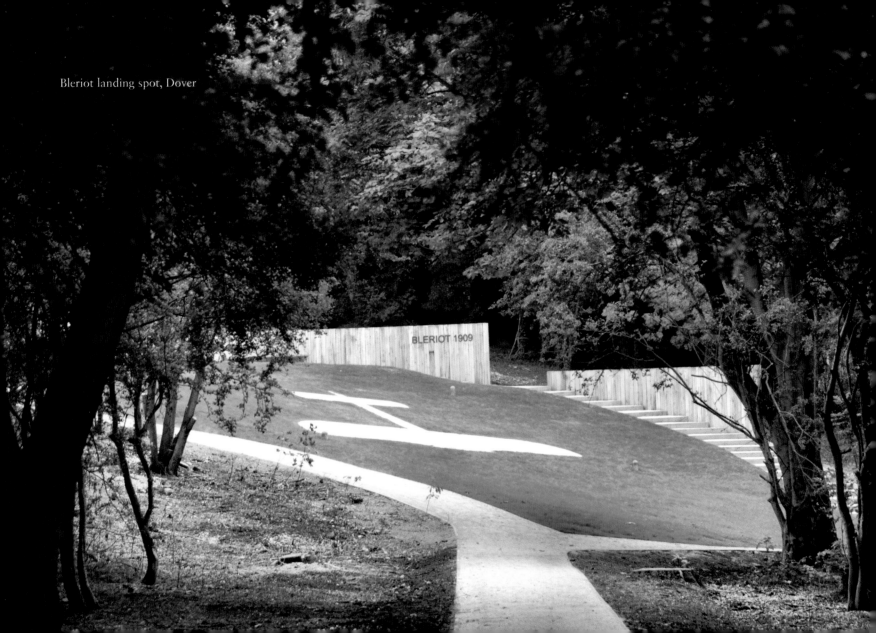

Bleriot landing spot, Dover

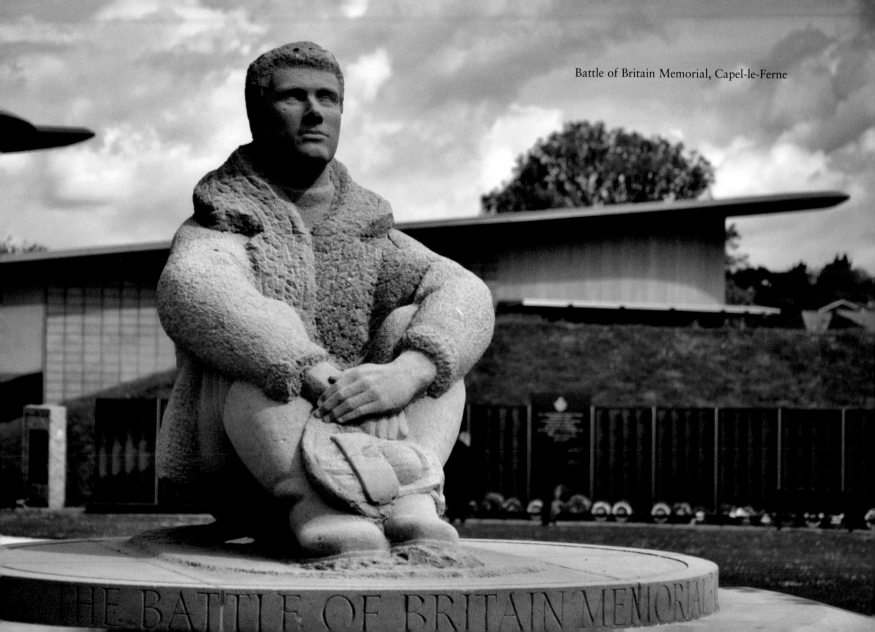

Battle of Britain Memorial, Capel-le-Ferne

Harvest time, Alkham Valley

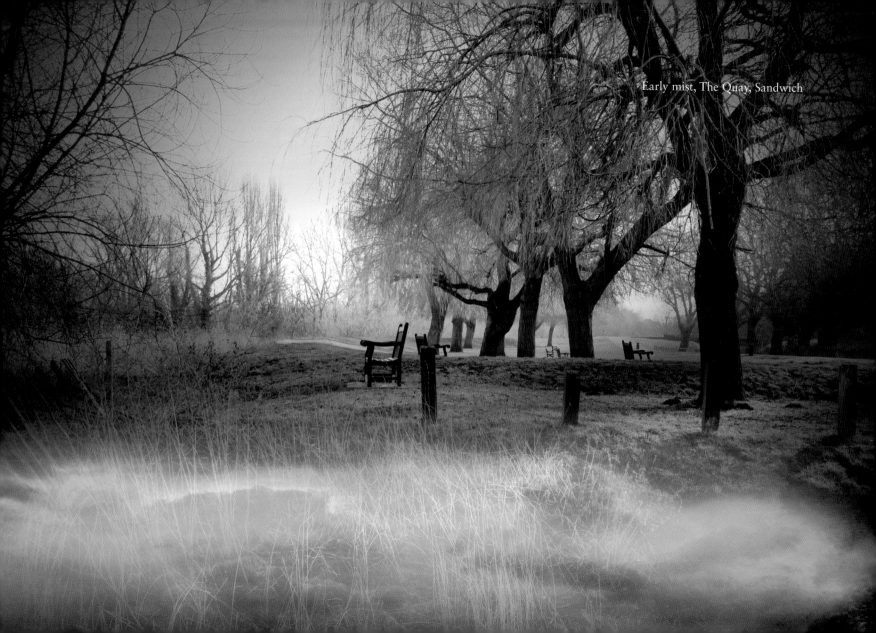

Early mist, The Quay, Sandwich

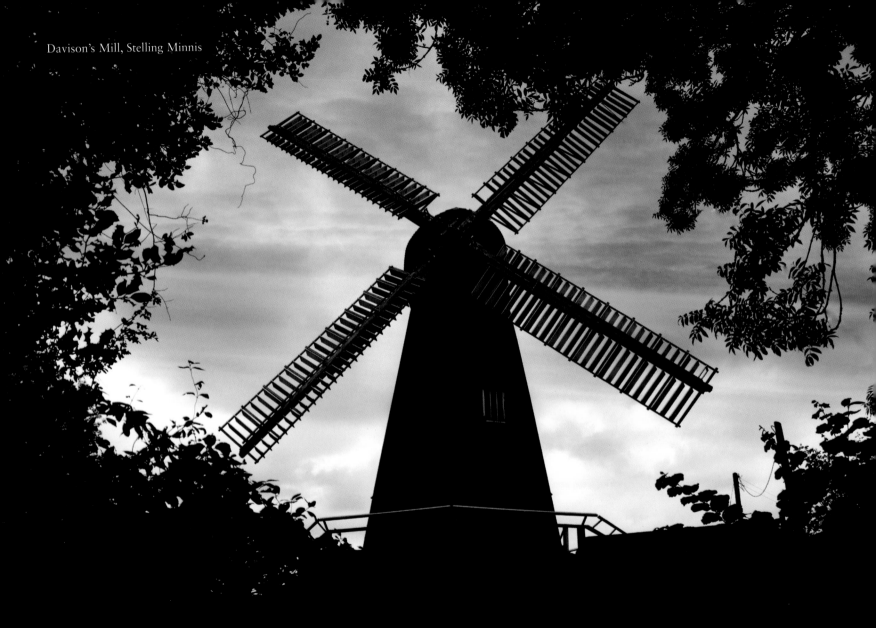

Davison's Mill, Stelling Minnis

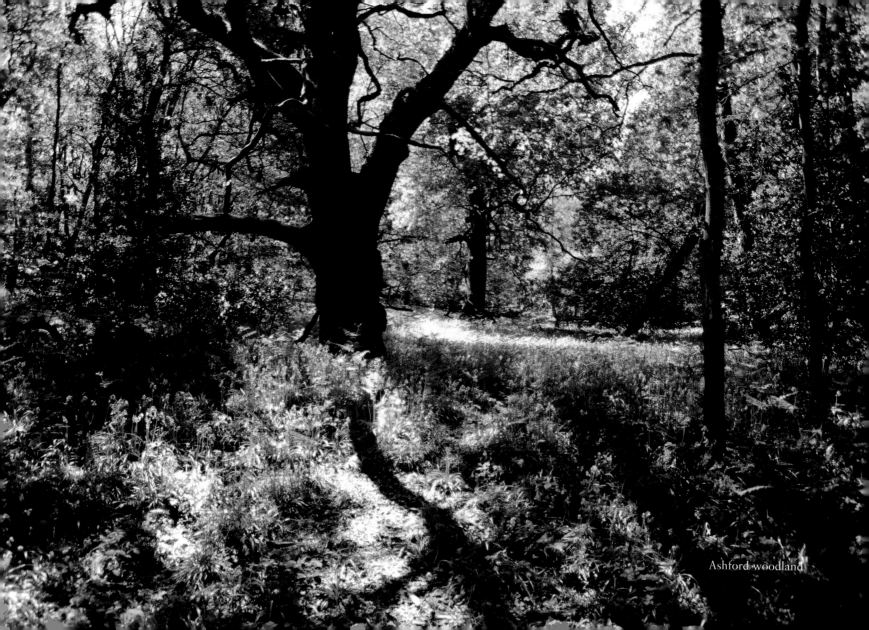

Ashford woodland

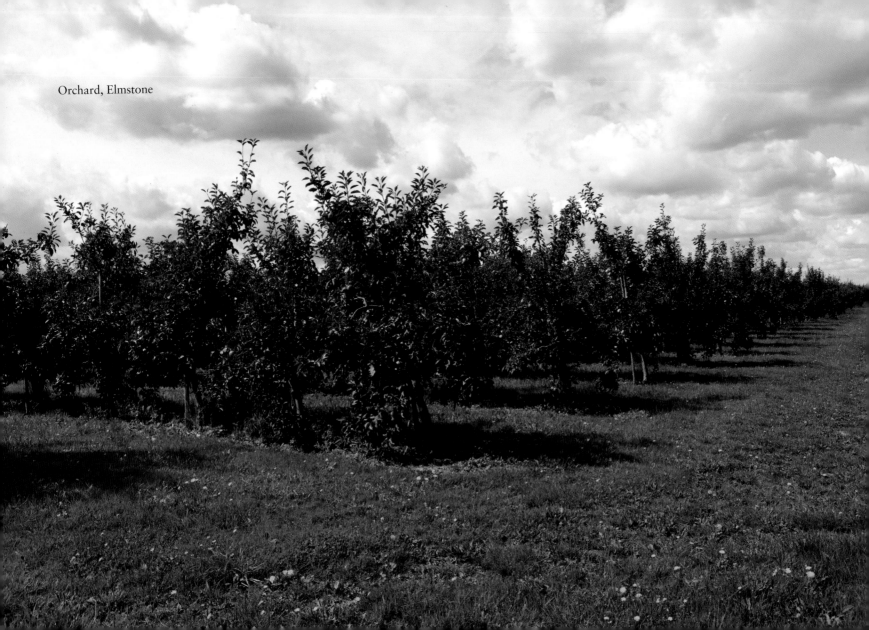

Orchard, Elmstone

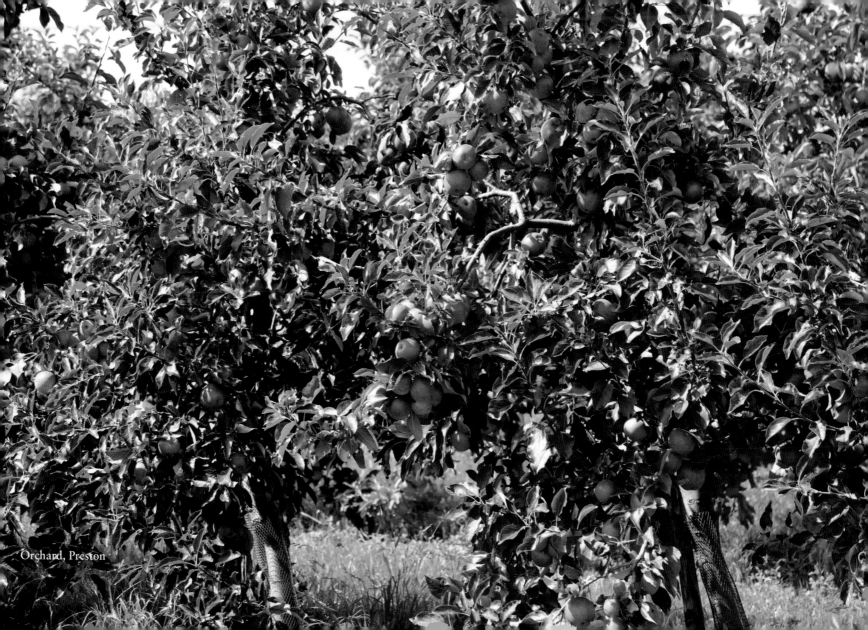

Orchard, Preston

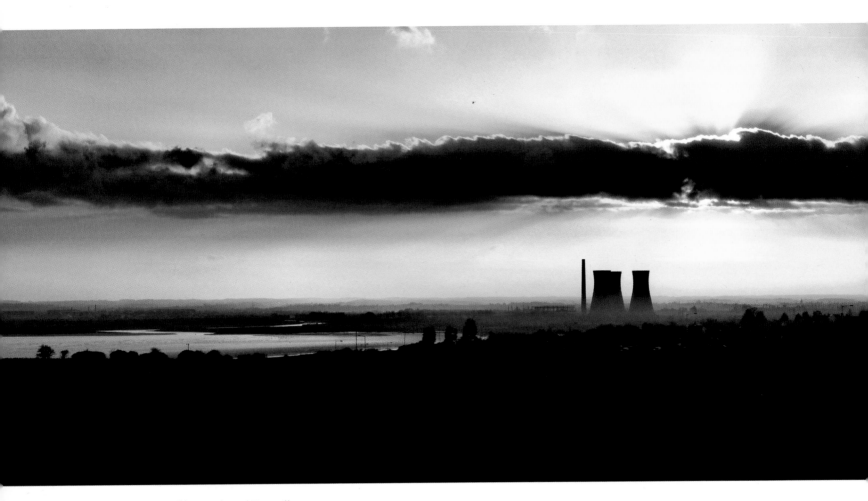

Power down, Port Richborough and Pegwell

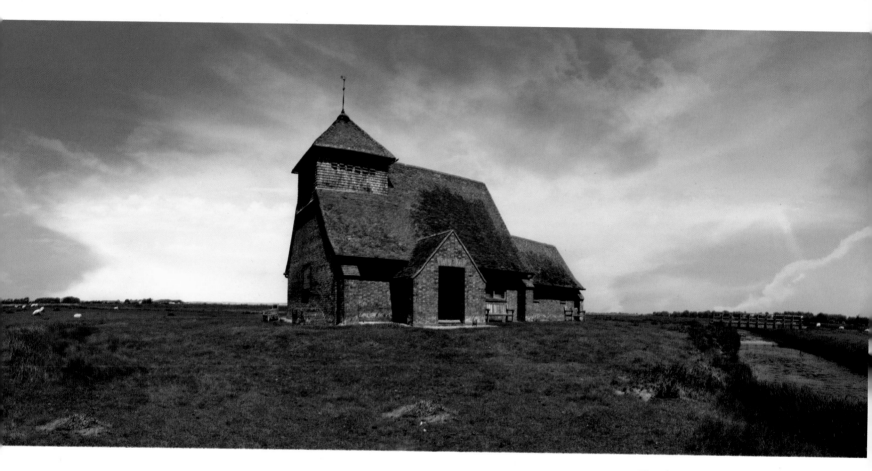

Church on the marsh, Fairfield

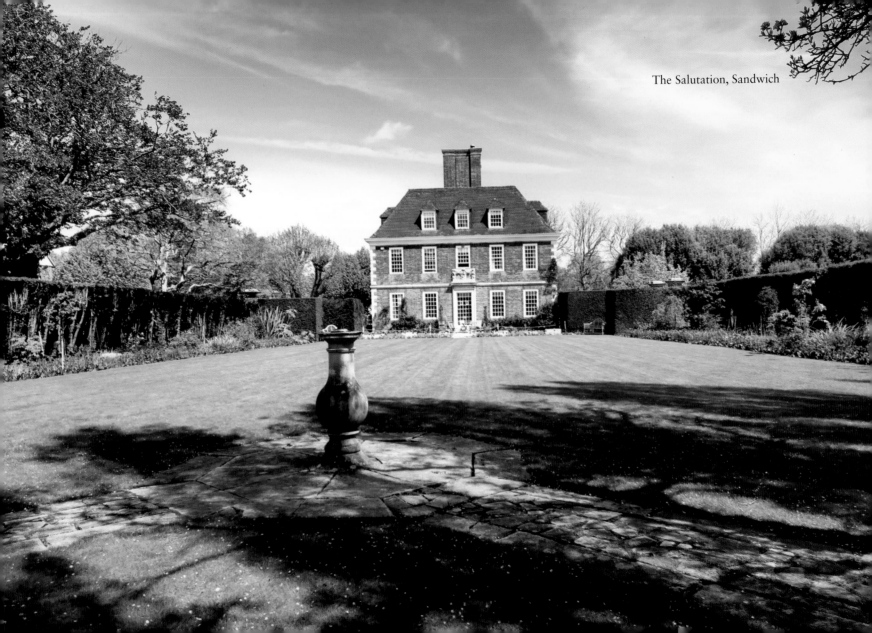

The Salutation, Sandwich

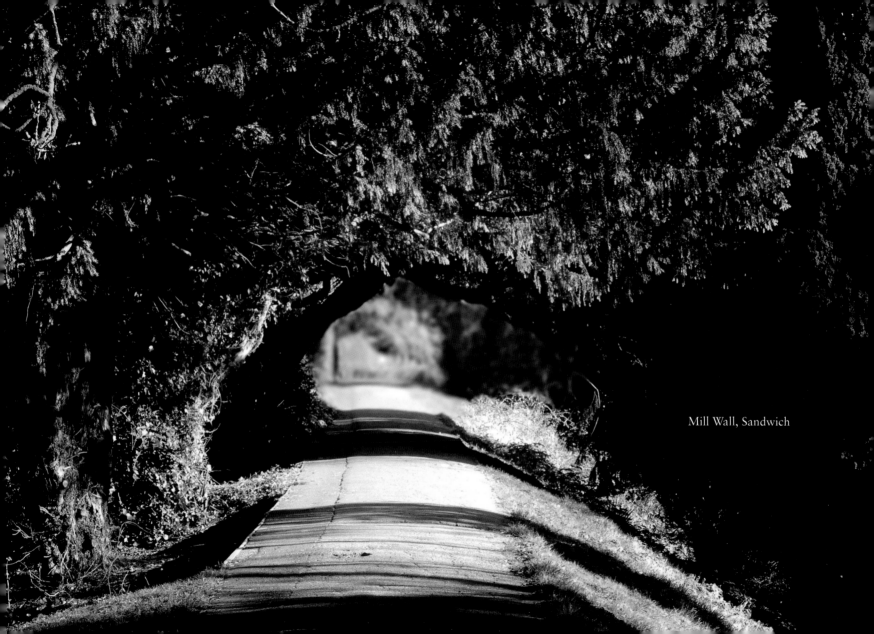

Mill Wall, Sandwich

SECRET SPACES

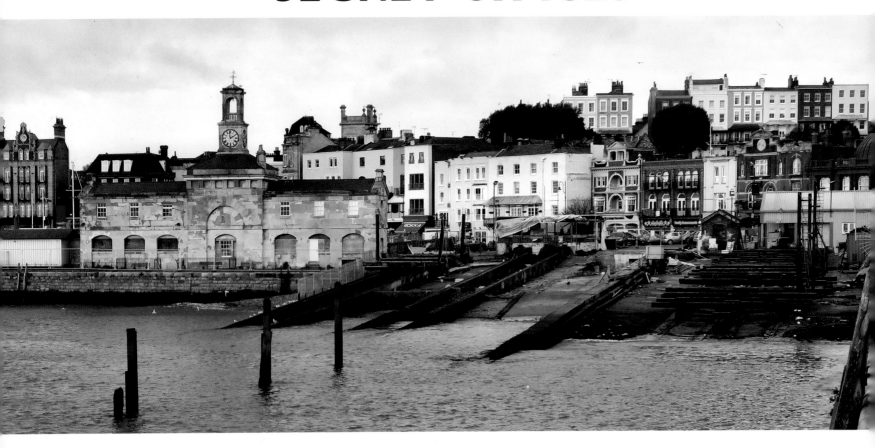

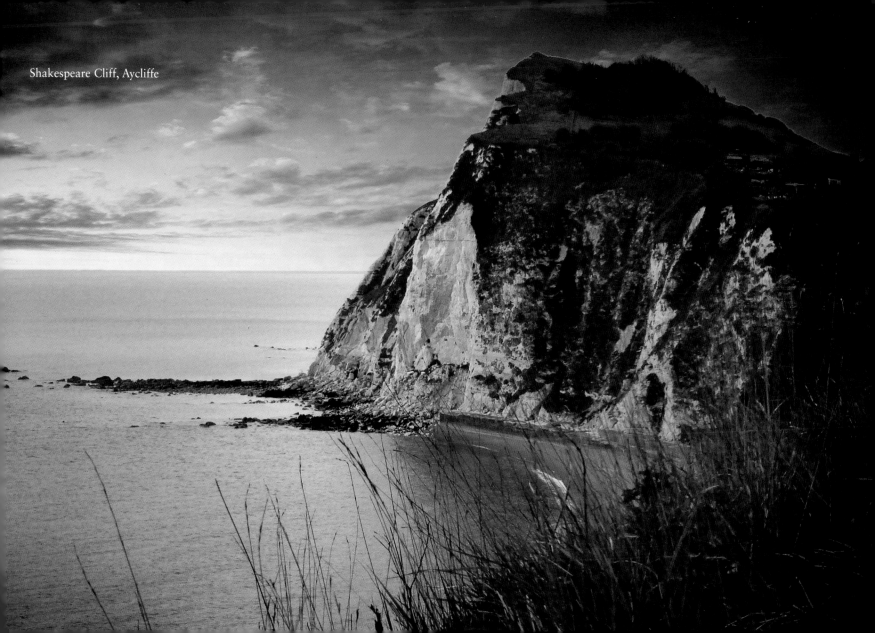

Shakespeare Cliff, Aycliffe

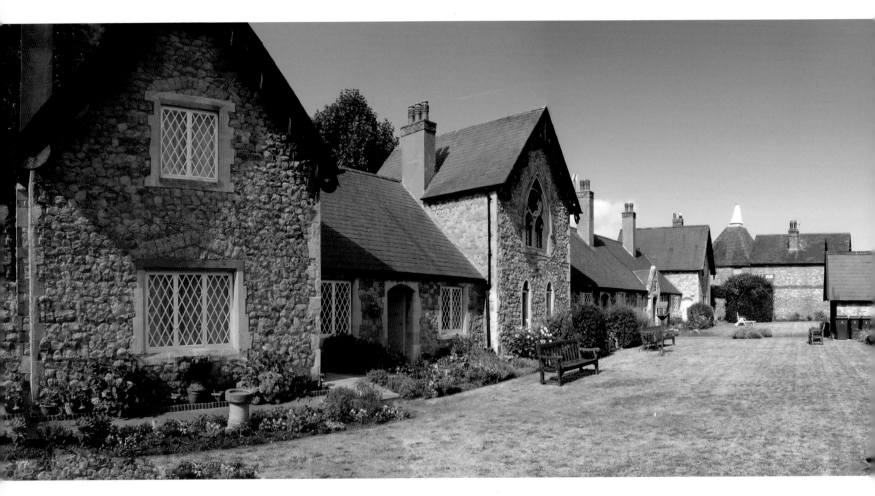

St Thomas's Hospital, Moat Sole, Sandwich

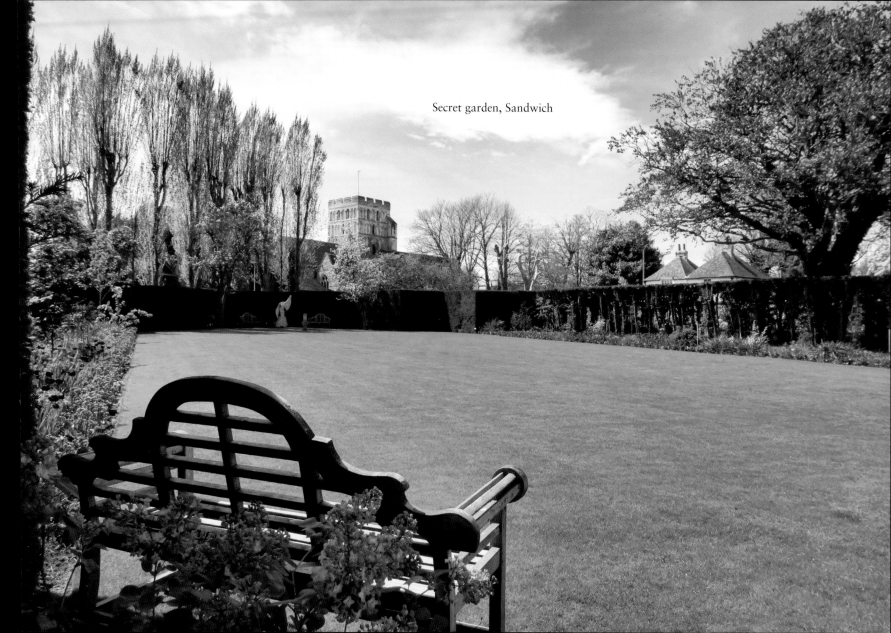

Secret garden, Sandwich

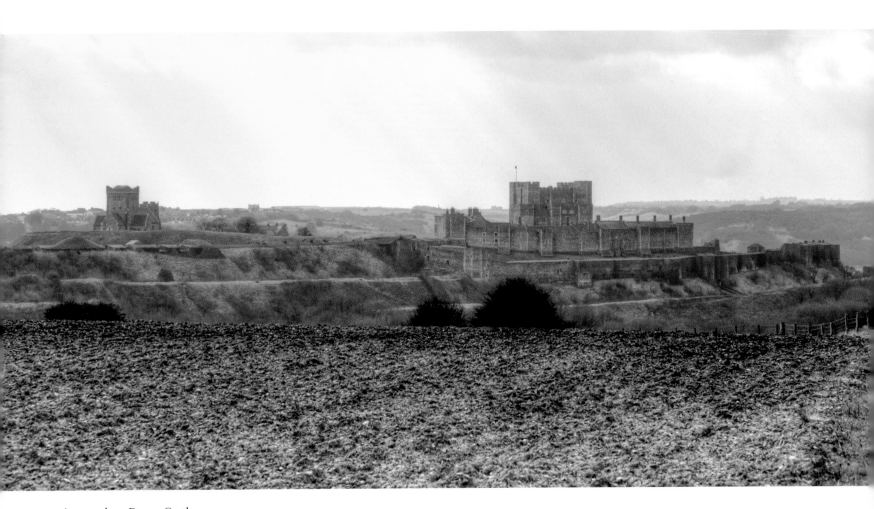

Approach to Dover Castle

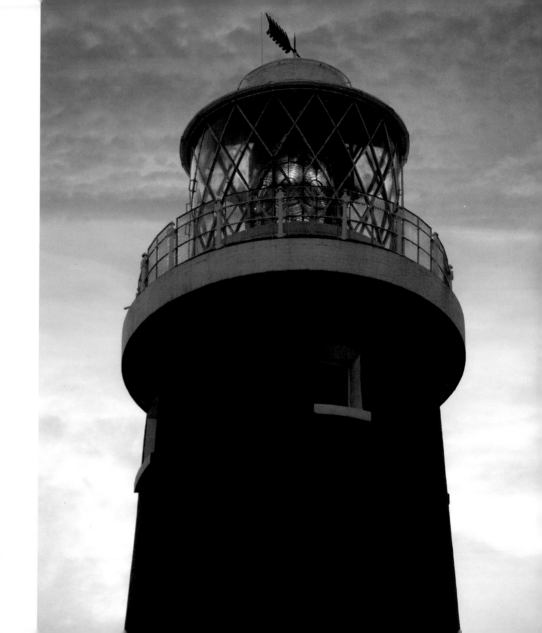

Dungeness Lighthouse

Walled garden, St Clement's

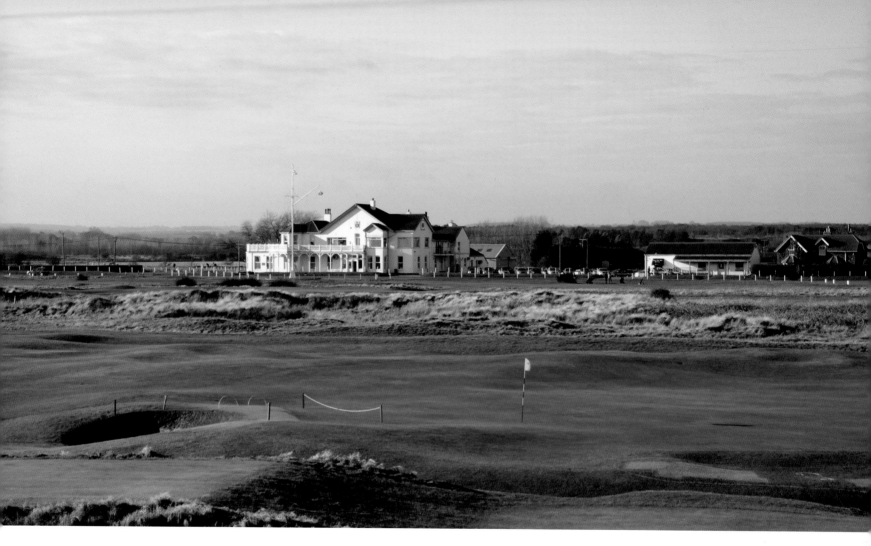

The clubhouse, Royal Cinque Ports Golf Club

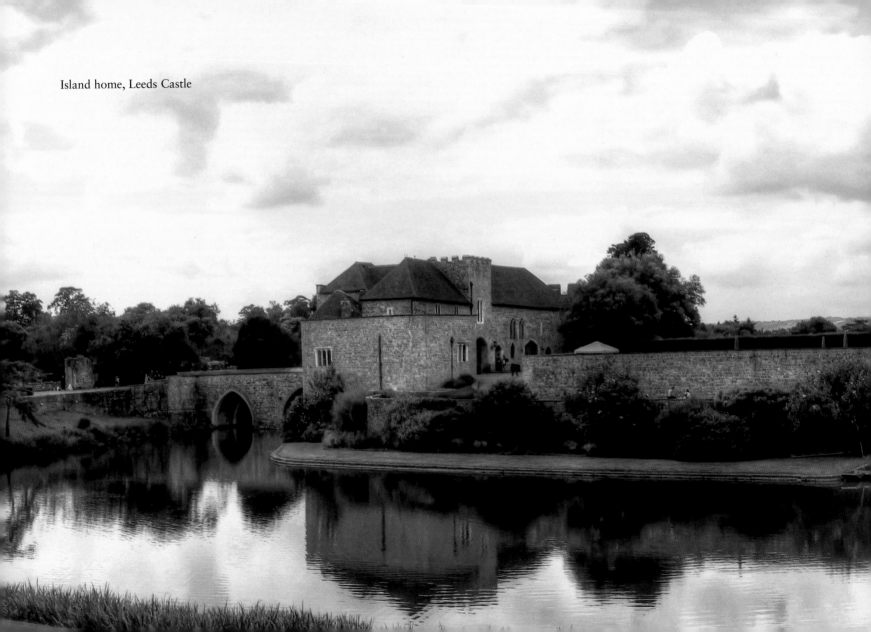

Island home, Leeds Castle

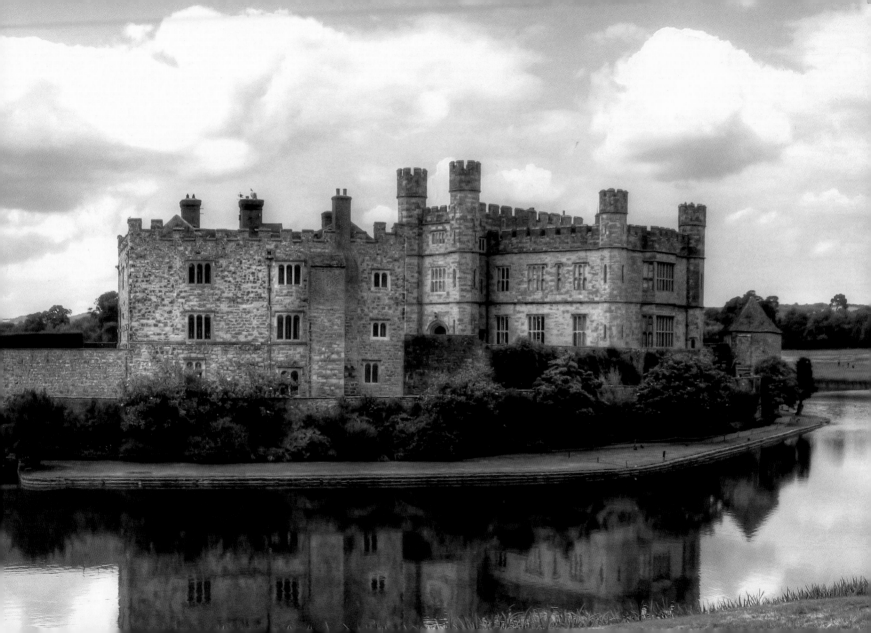

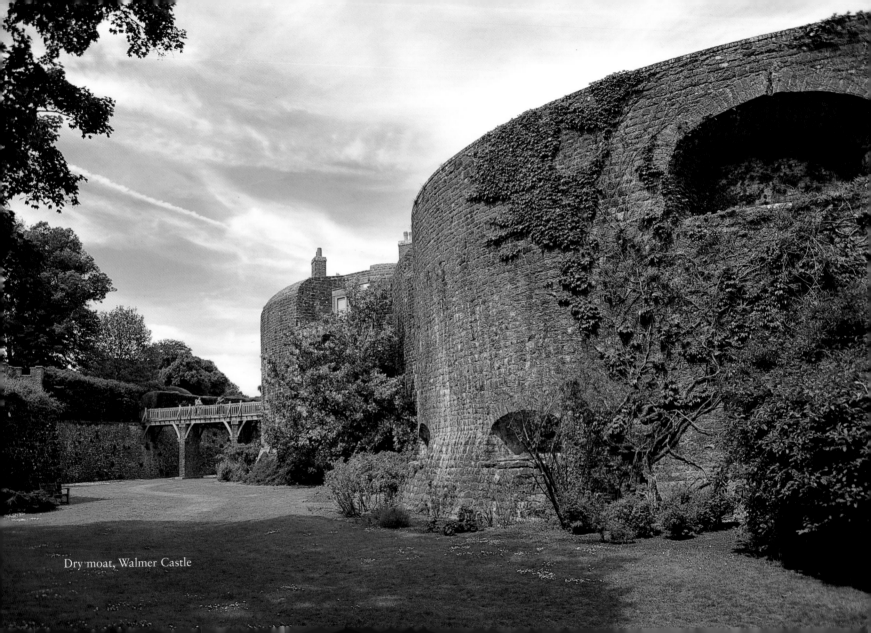

Dry moat, Walmer Castle

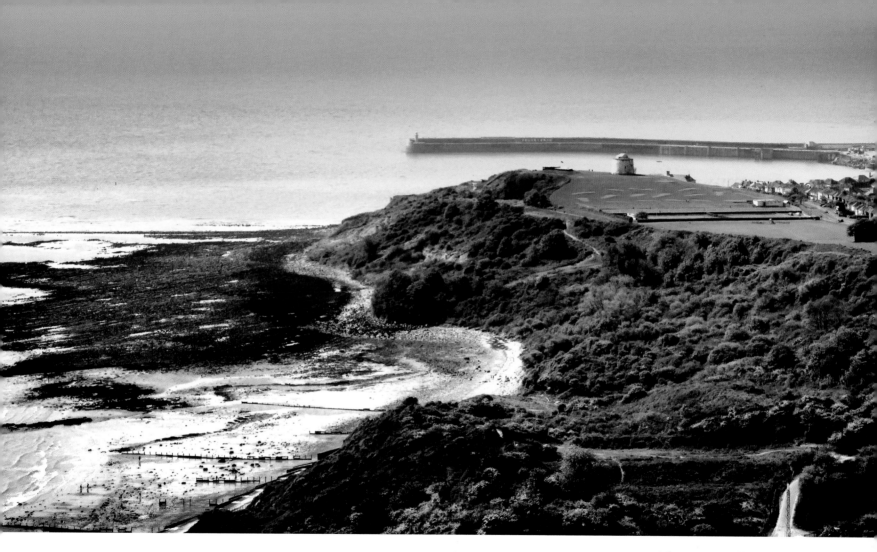

The Warren, Folkestone

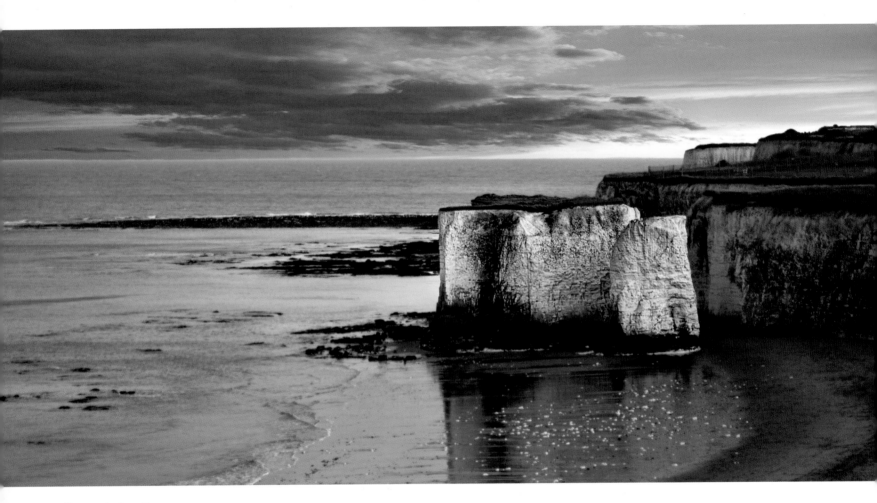

Sea stack, Joss Bay

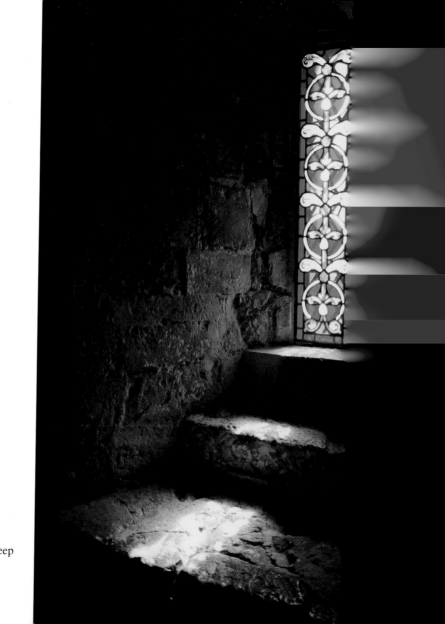

Queen's Chapel window, Dover Castle keep

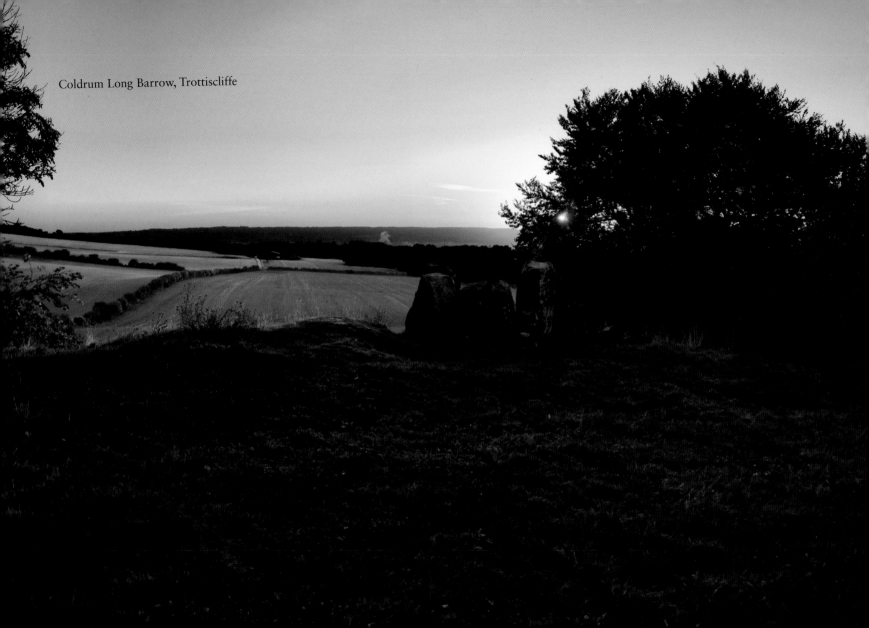

Coldrum Long Barrow, Trottiscliffe

A Spitfire and Hurricane over Lydd

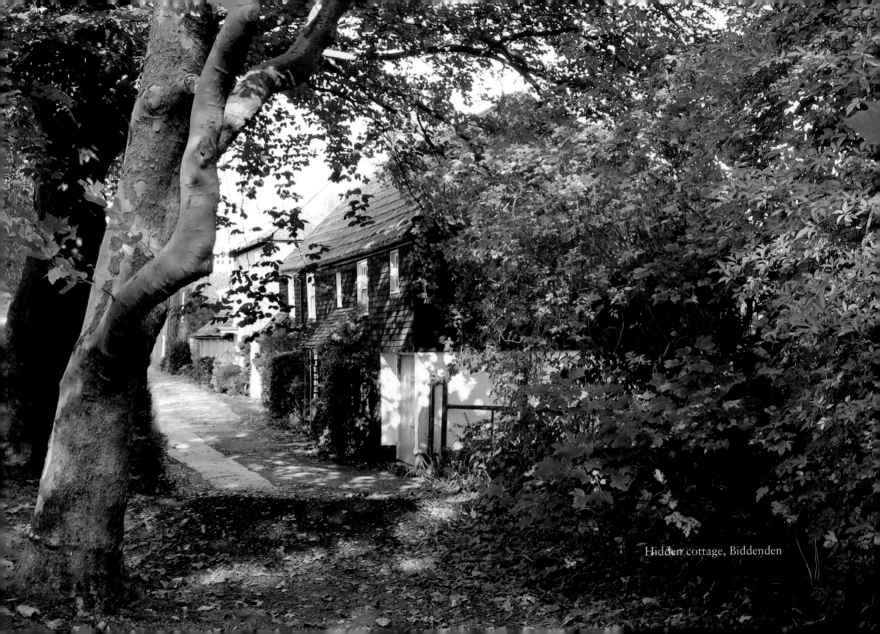

Hidden cottage, Biddenden

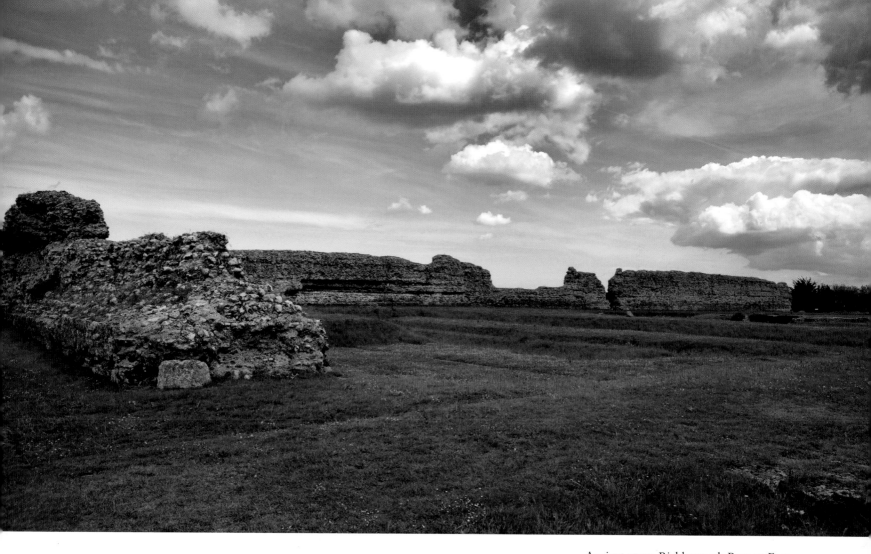

Ancient steps, Richborough Roman Fort

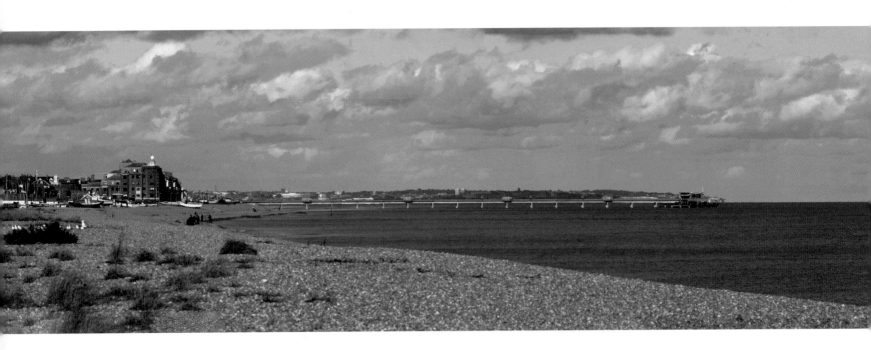

Deal seafront

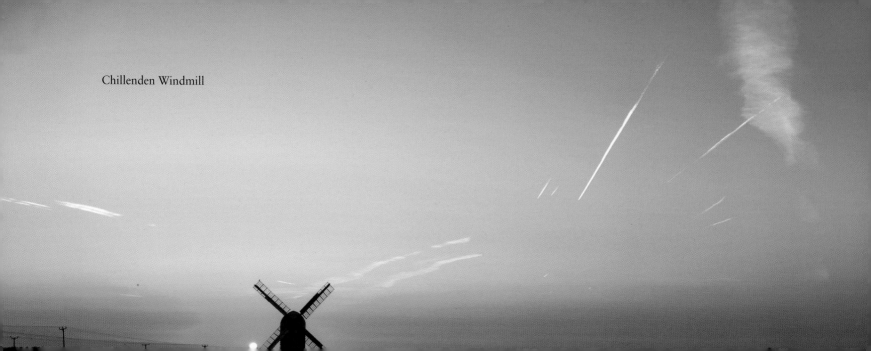

Chillenden Windmill

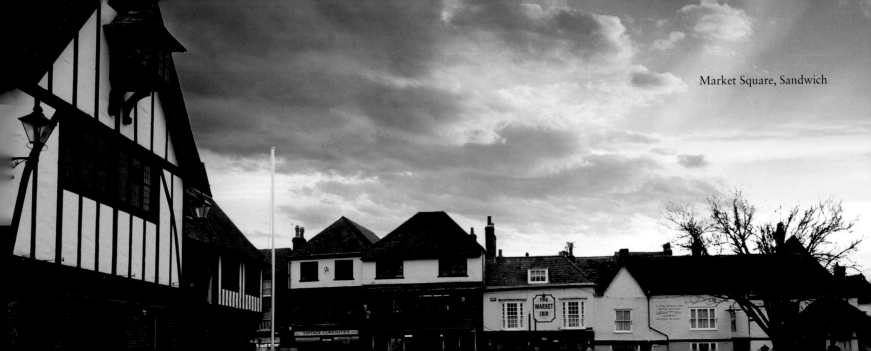

Market Square, Sandwich

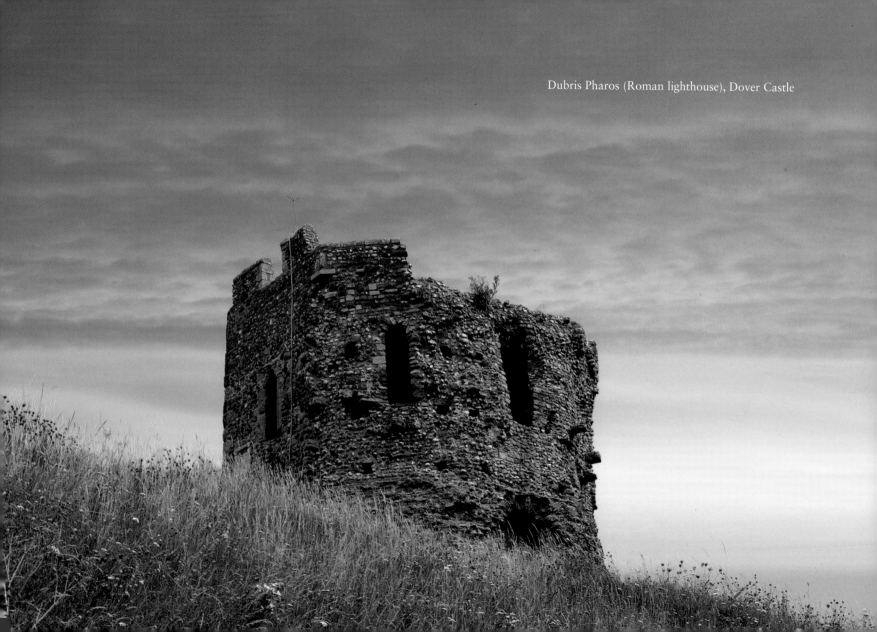

Dubris Pharos (Roman lighthouse), Dover Castle

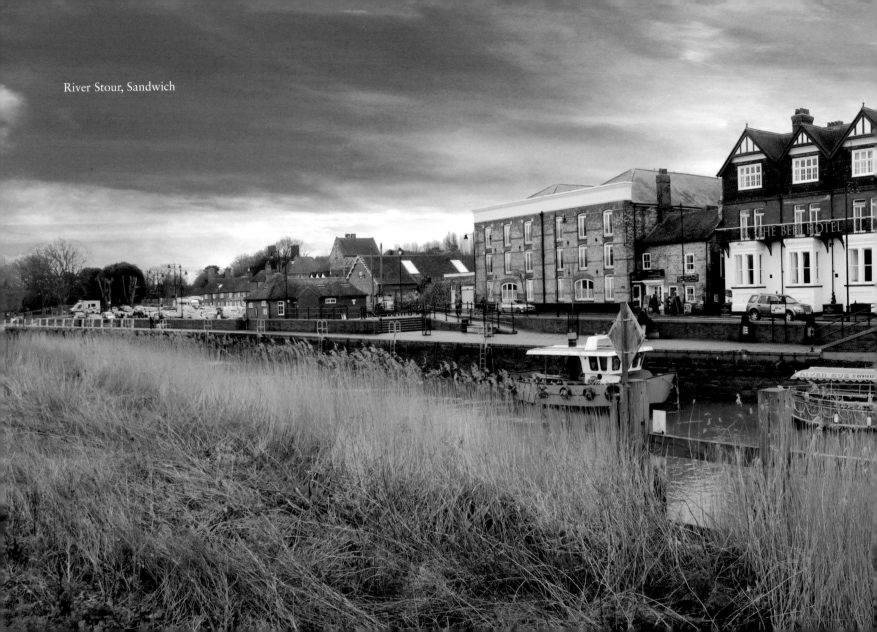

River Stour, Sandwich

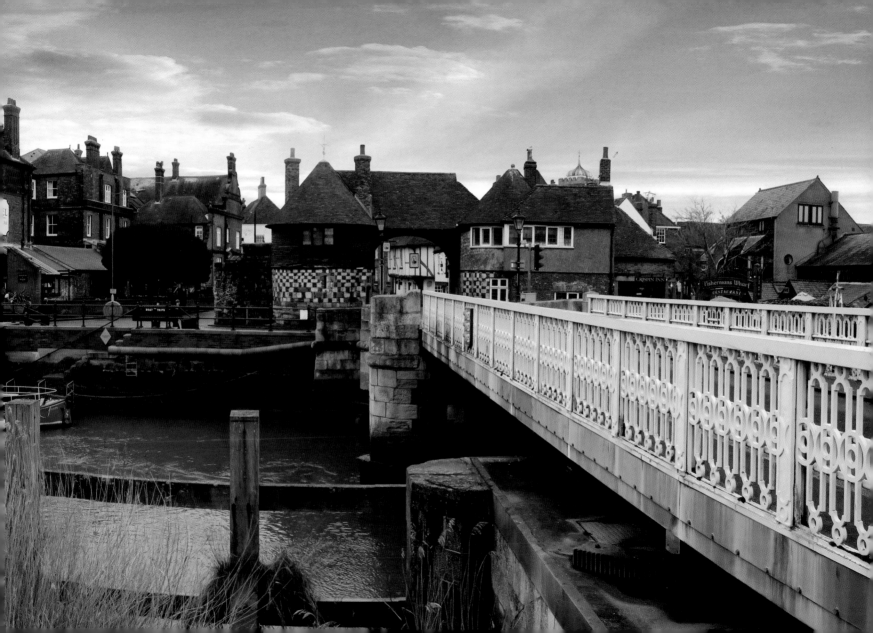

HERE AND THERE

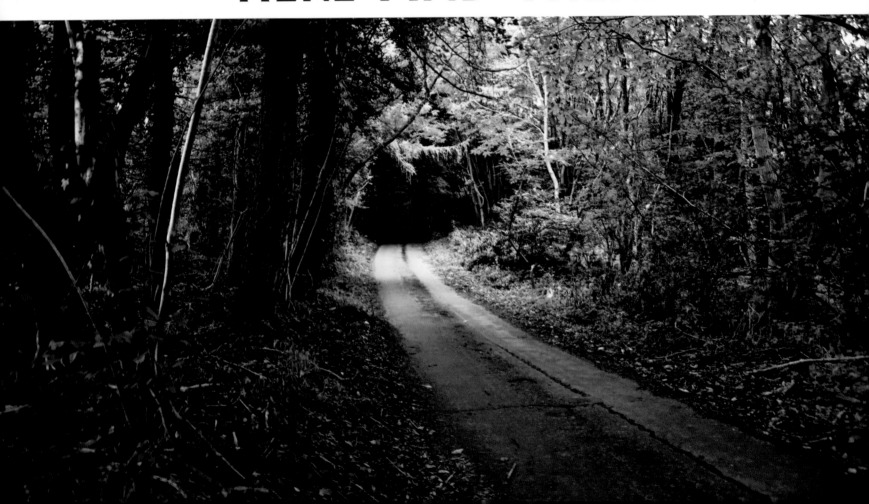

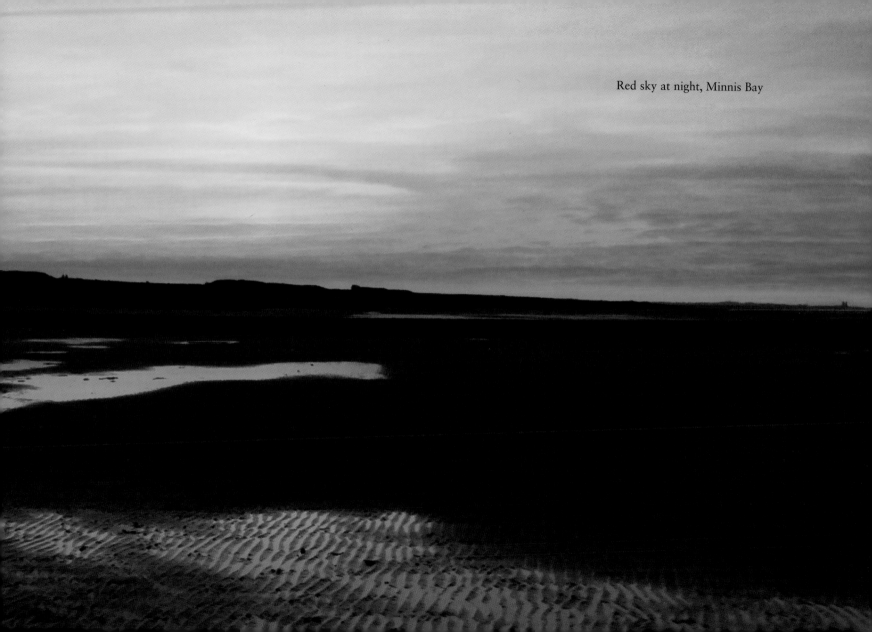

Red sky at night, Minnis Bay

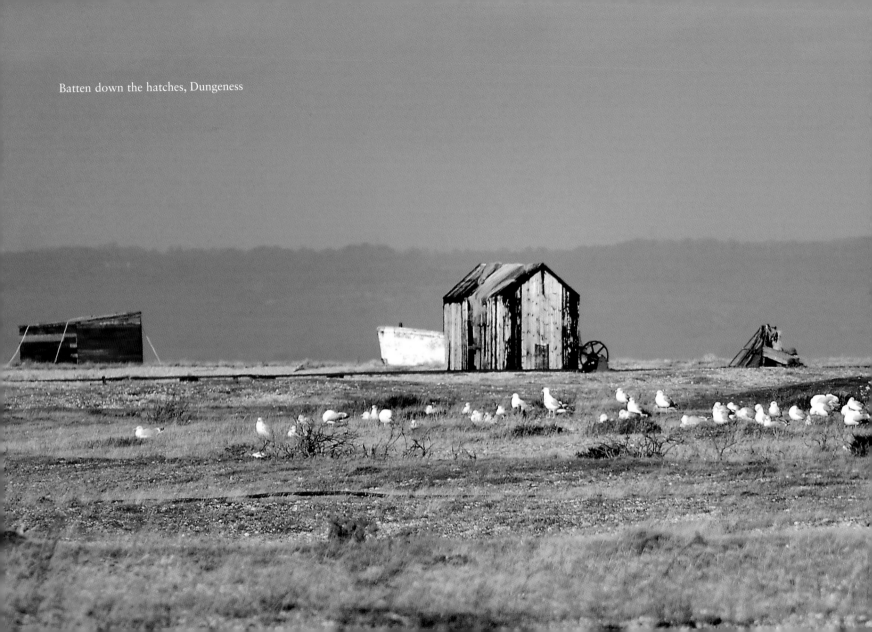

Batten down the hatches, Dungeness

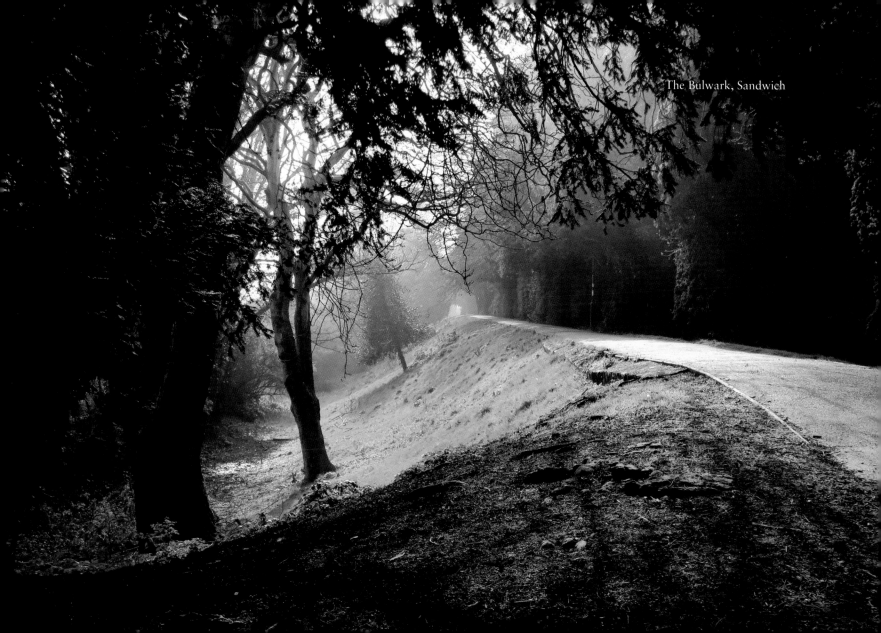

The Bulwark, Sandwich

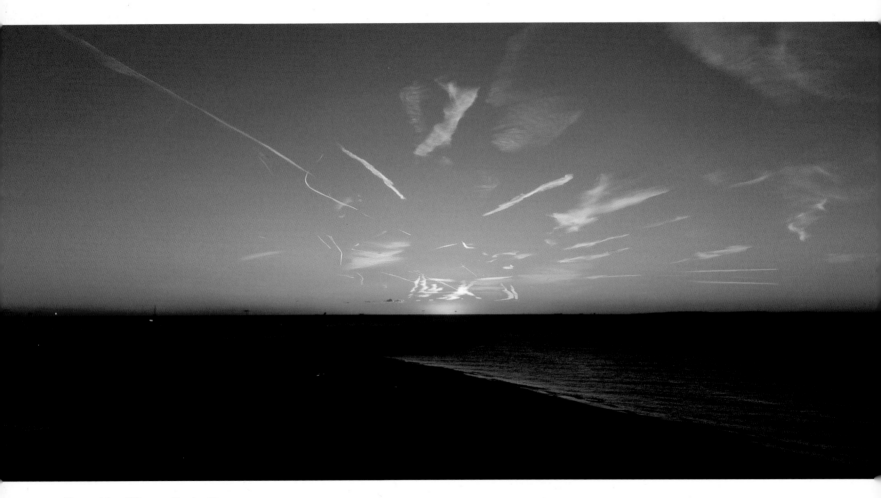

Sky writing, Western Docks, Dover

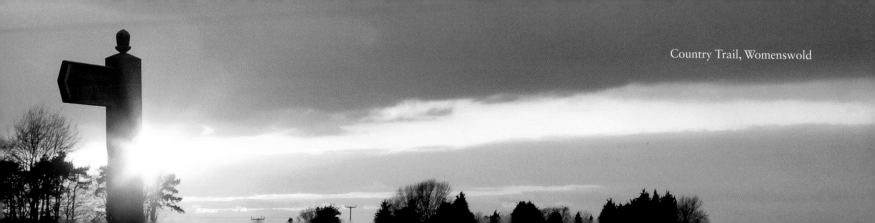

Country Trail, Womenswold

Oast houses, Goudhurst

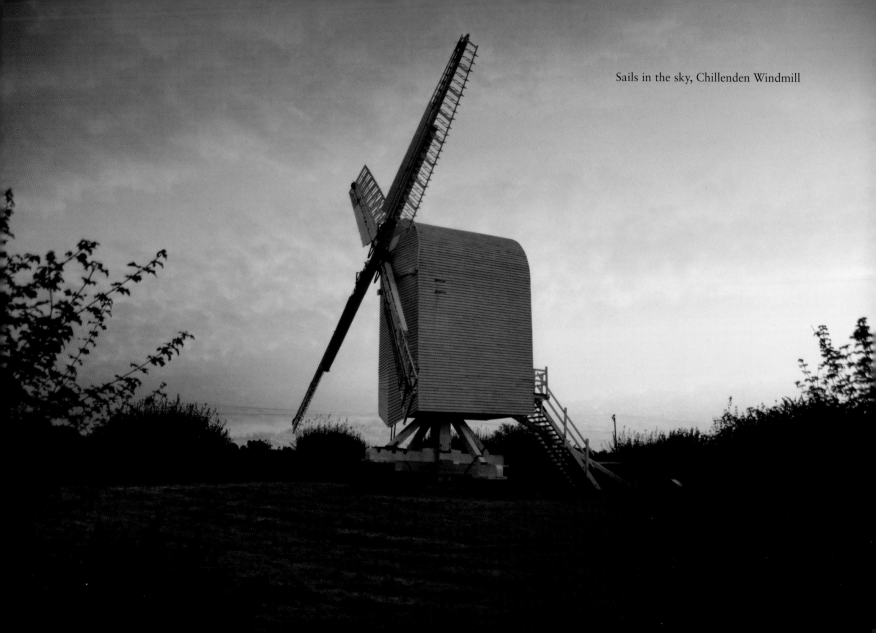

Sails in the sky, Chillenden Windmill

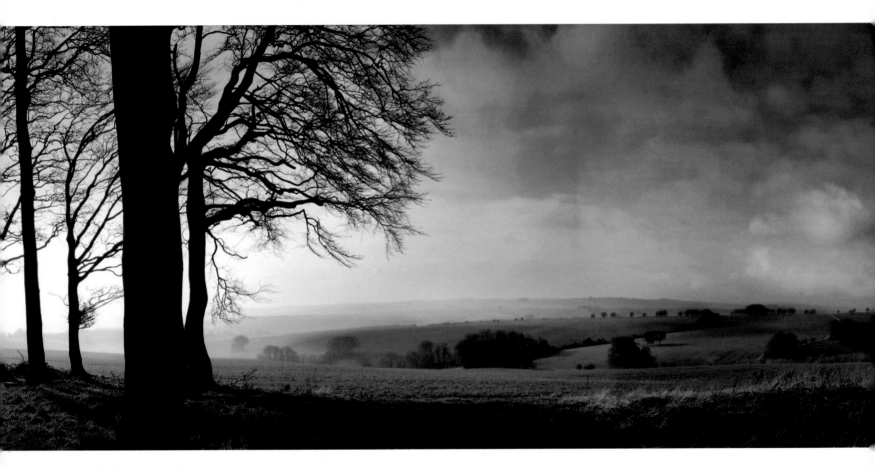

Up on the downs, North Downs, East Brabourne

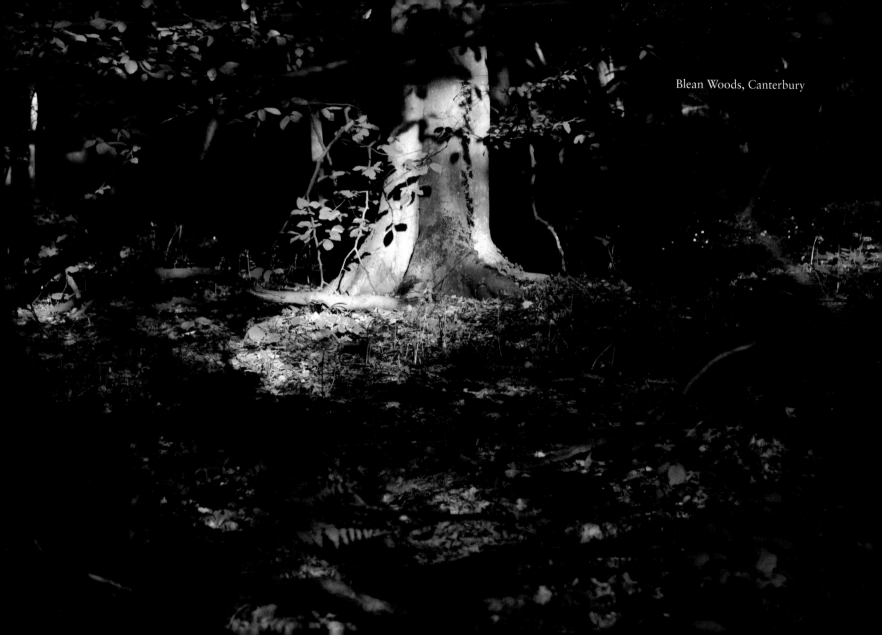

Blean Woods, Canterbury

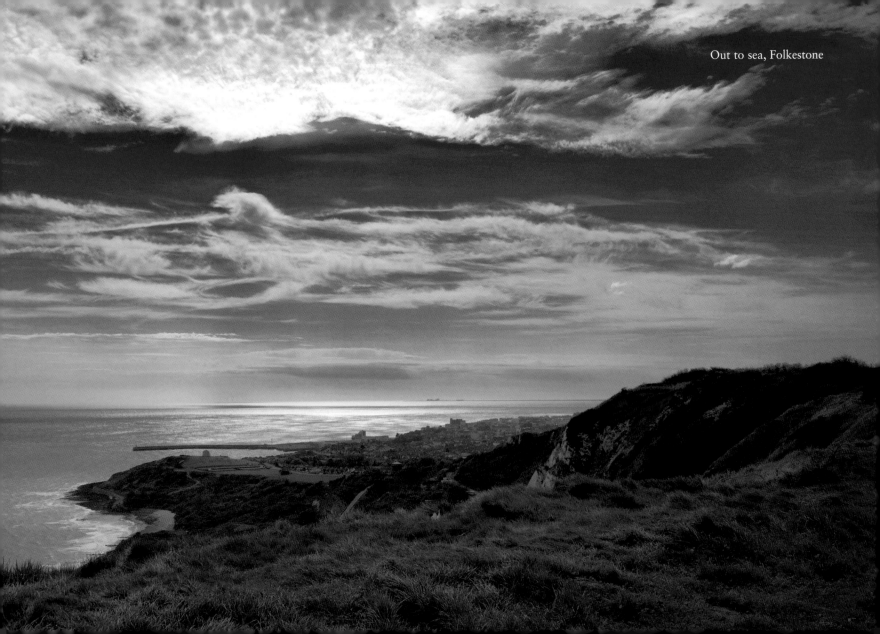

Out to sea, Folkestone

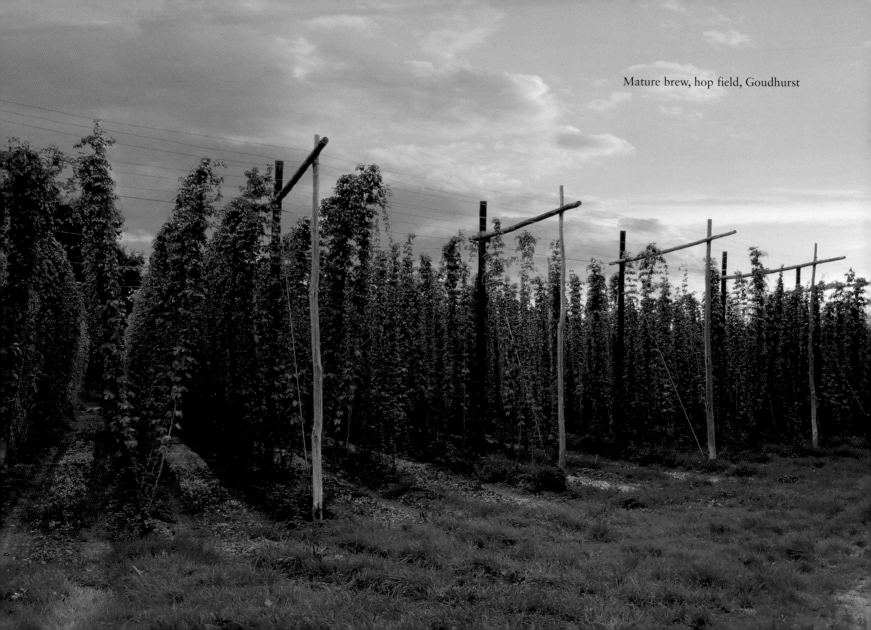

Mature brew, hop field, Goudhurst

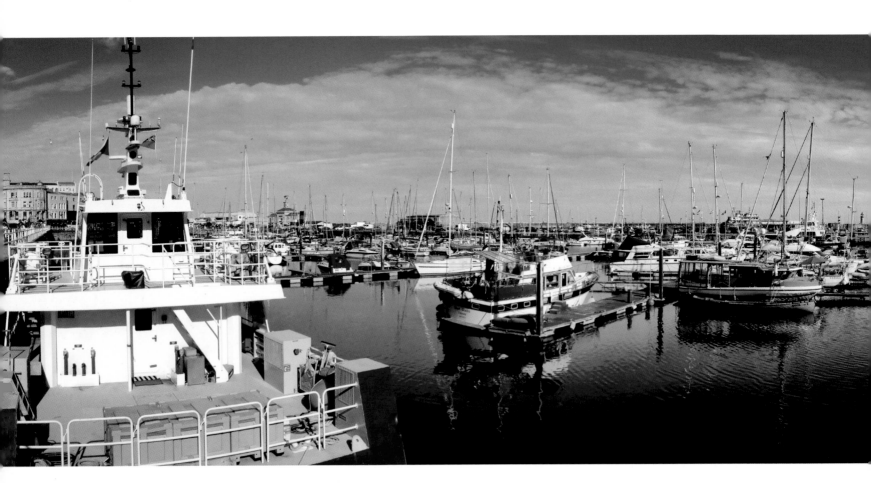

Royal Harbour, Ramsgate

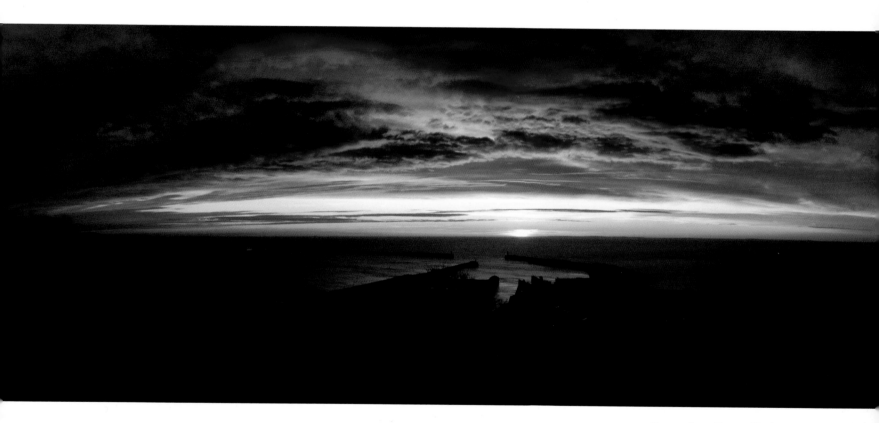

Dawn glory, Dover Harbour

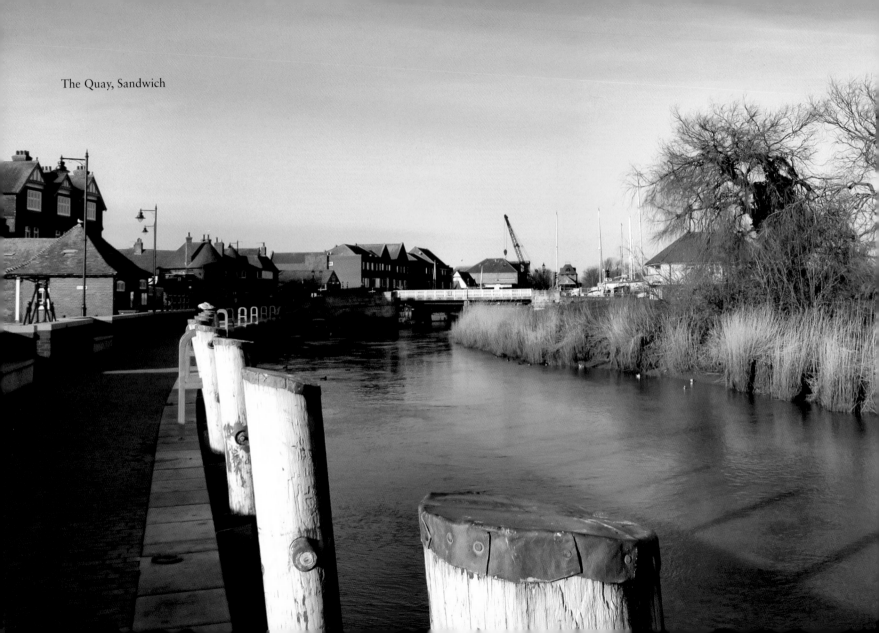

The Quay, Sandwich

Blean Woods, Canterbury

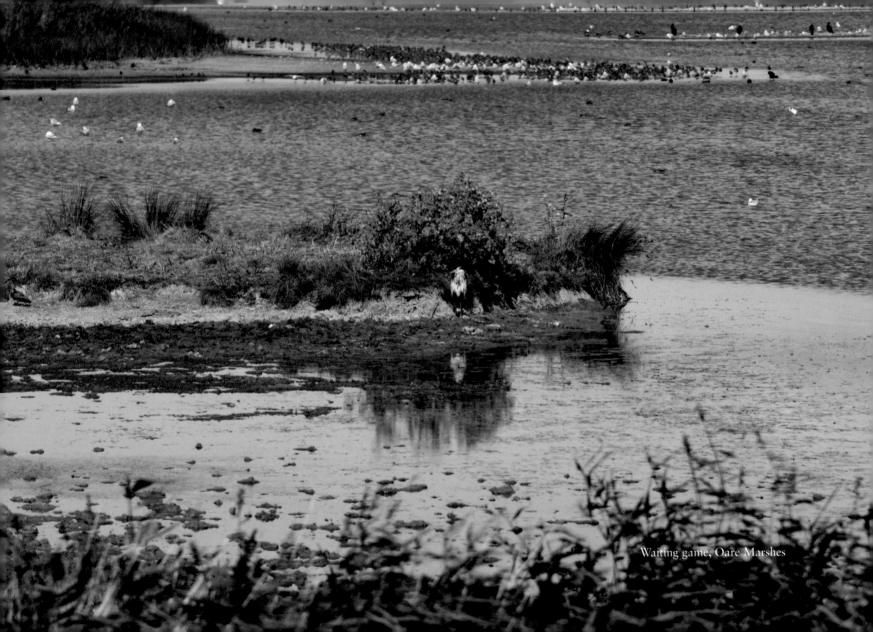

Waiting game, Oare Marshes

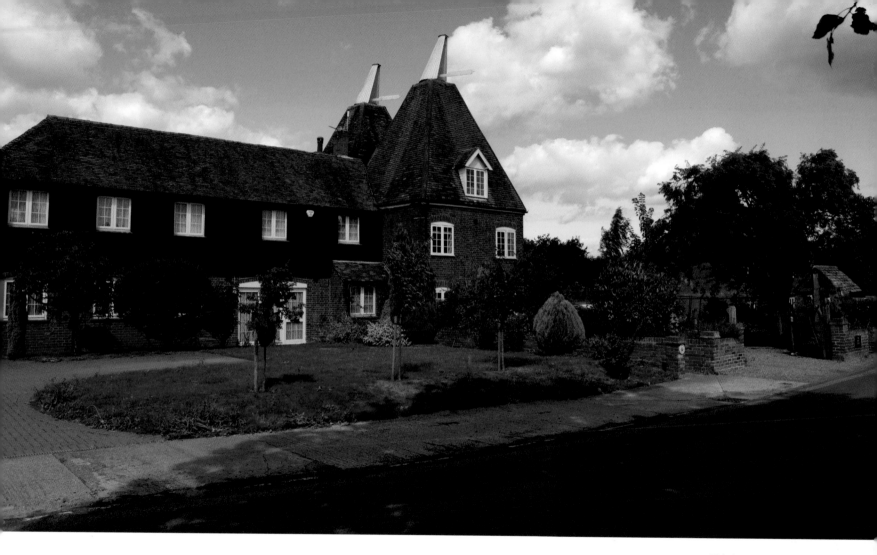

Old Oast, Preston

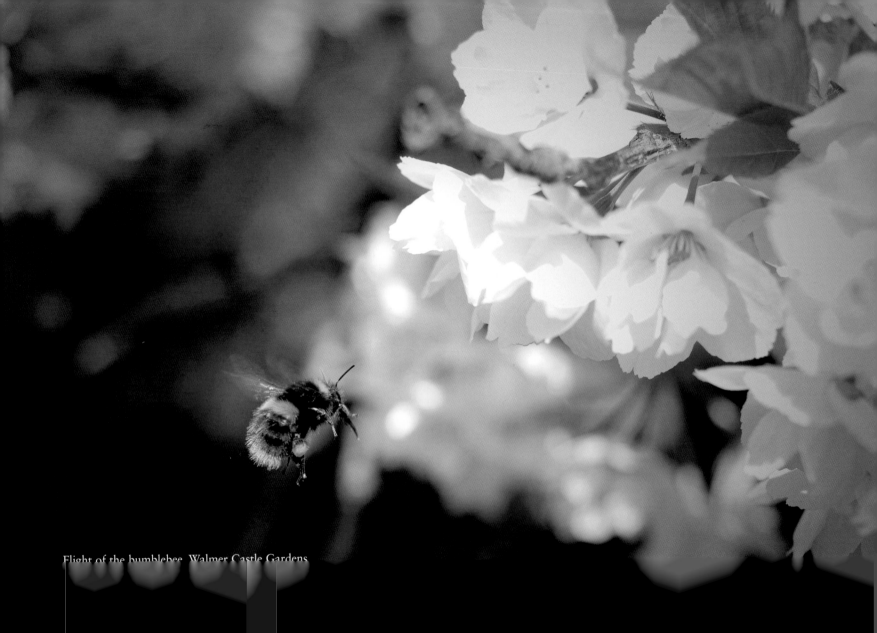

Flight of the bumblebee, Walmer Castle Gardens

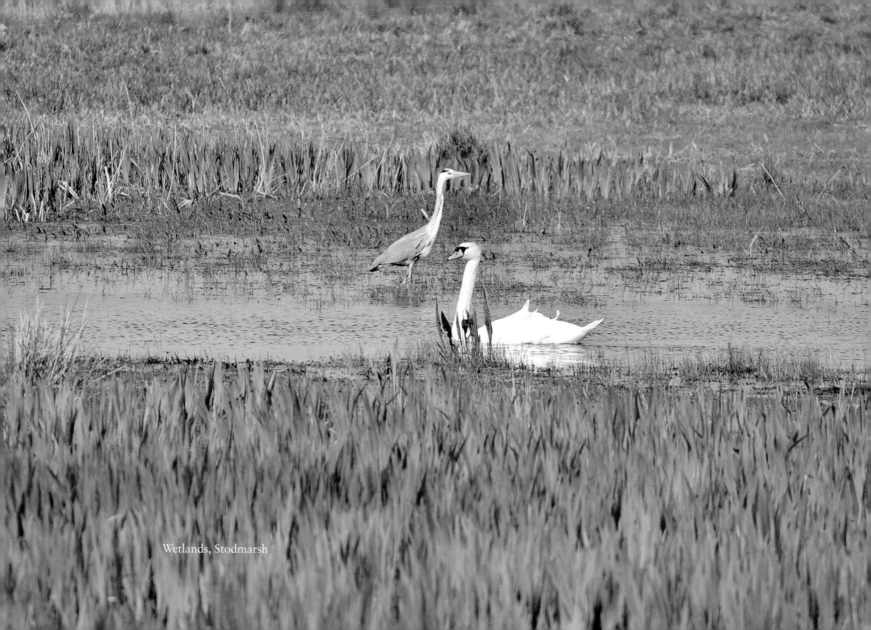

Wetlands, Stodmarsh

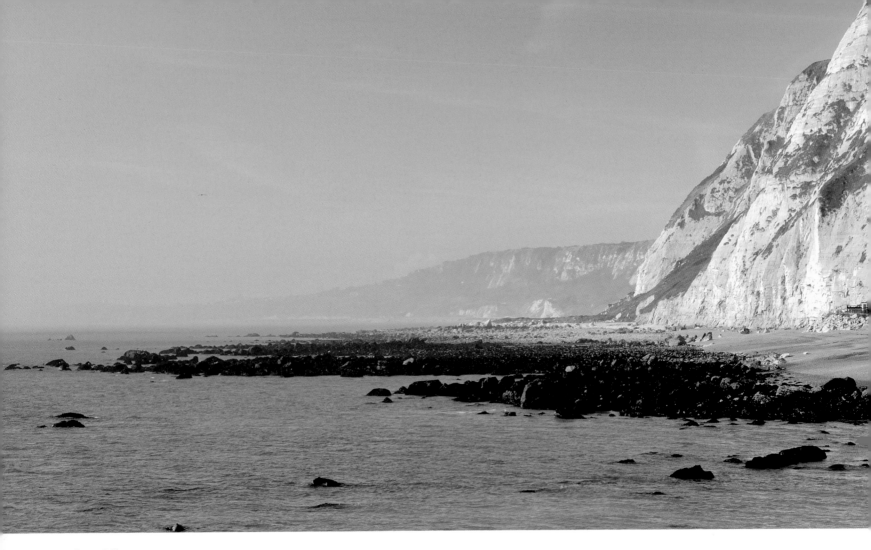

White cliffs, Dover

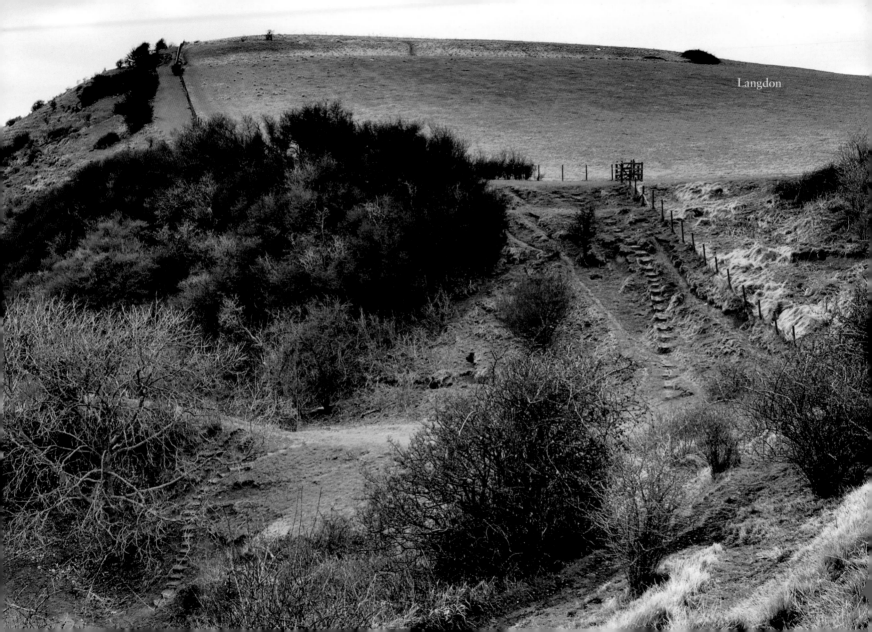
Langdon

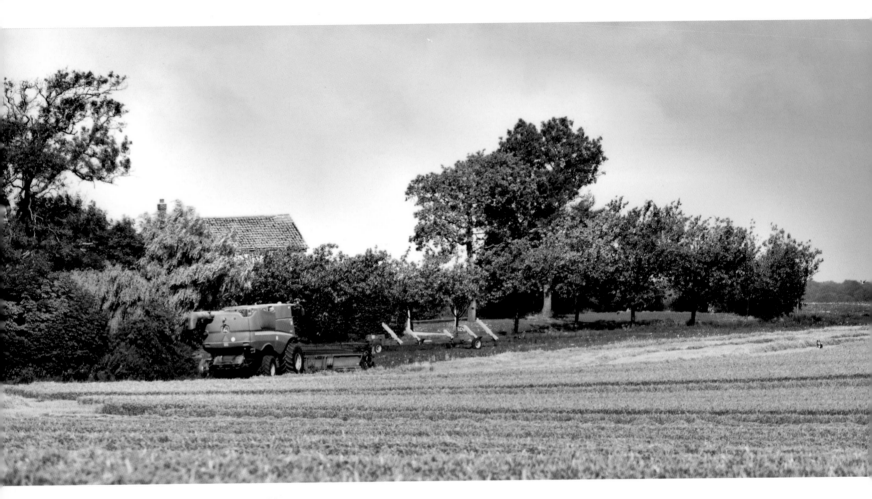

Crop mechanics, Cauldham Farm, Capel-le-Ferne

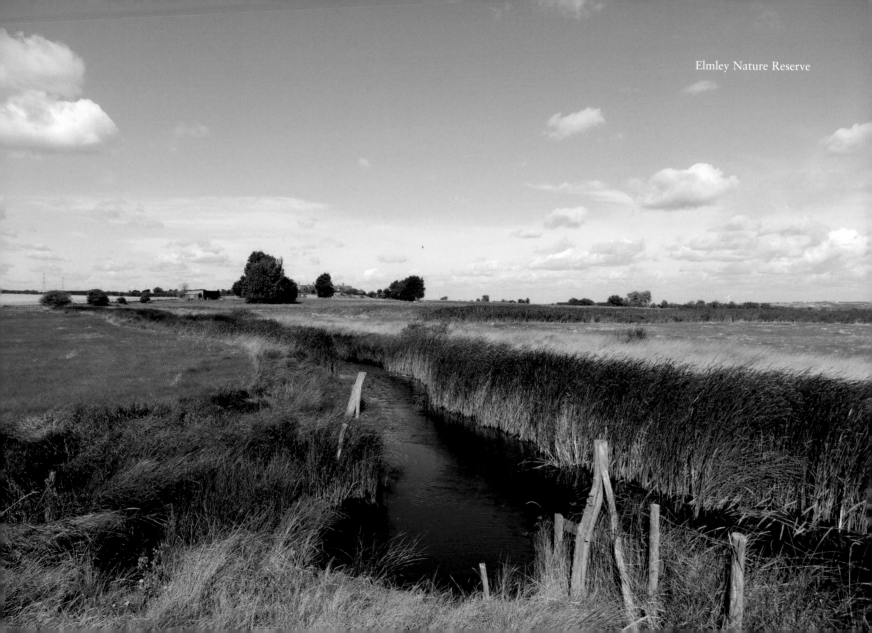

Elmley Nature Reserve

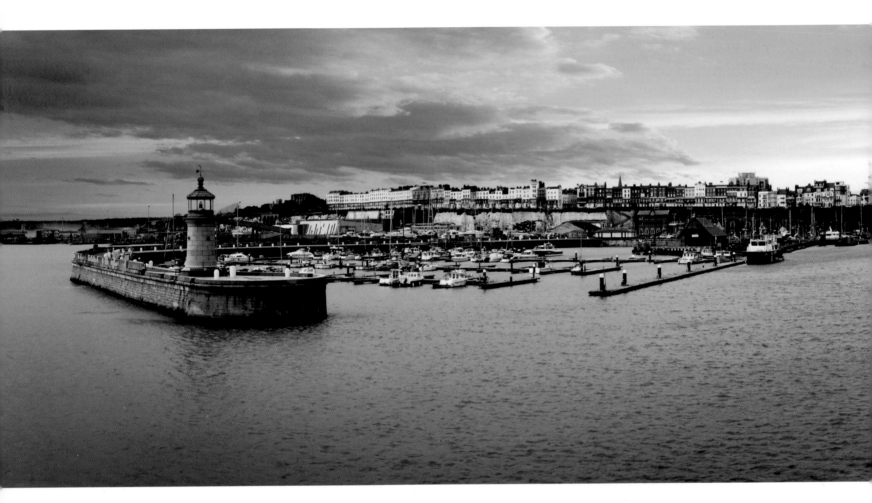

West Pier Lighthouse, Ramsgate

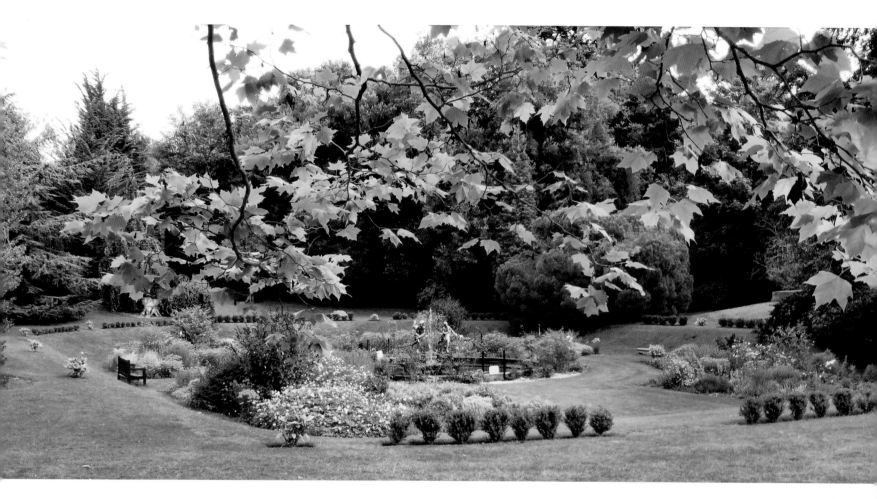

Garden pride, Quex Park Gardens

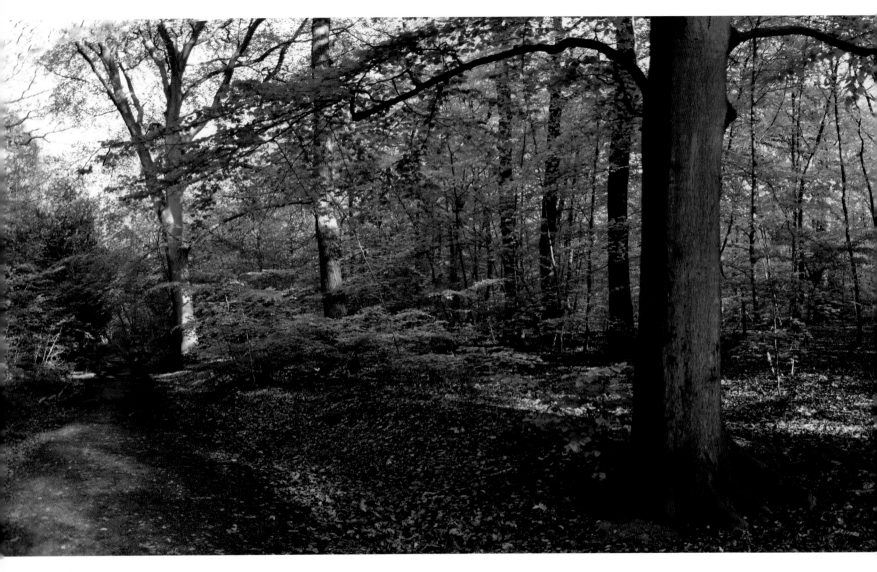

Blean Nature Reserve

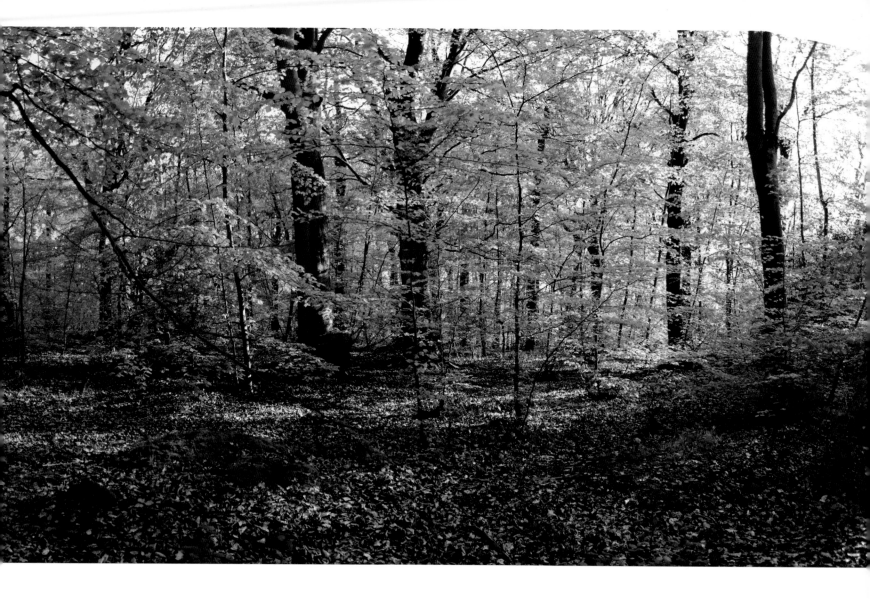

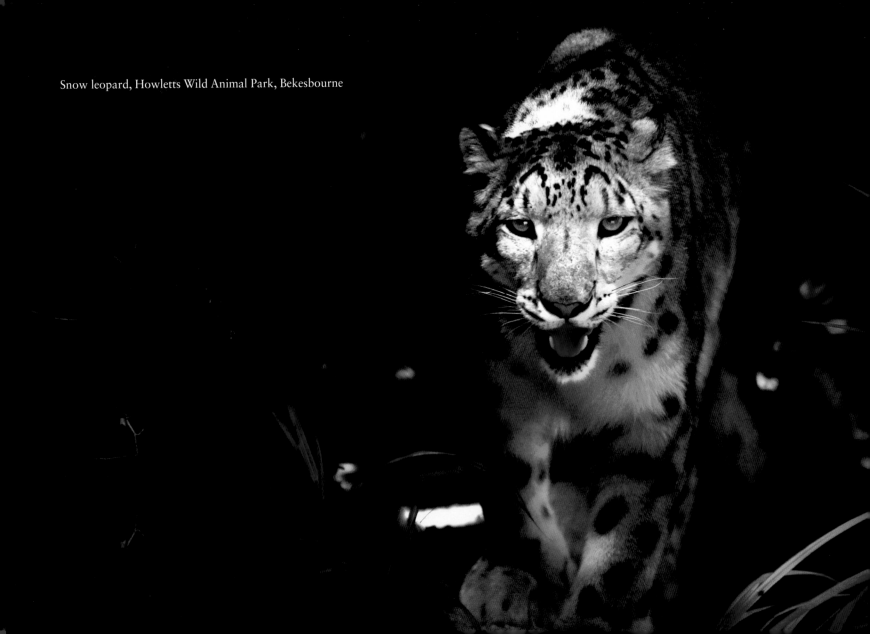

Snow leopard, Howletts Wild Animal Park, Bekesbourne

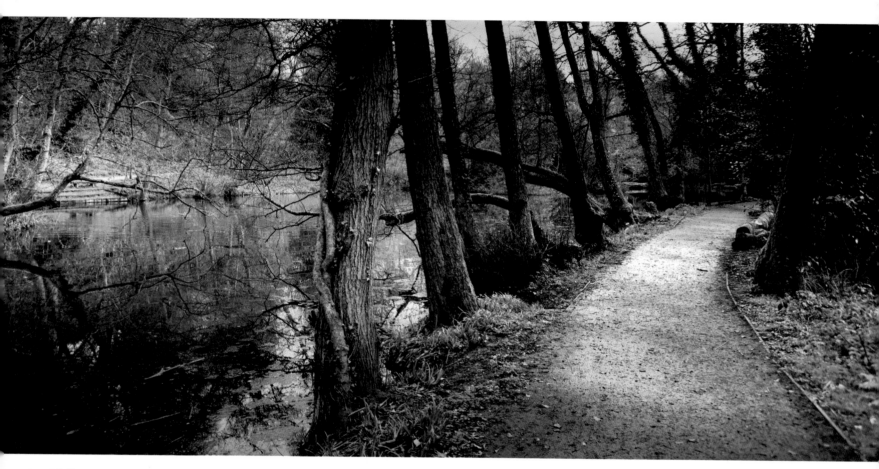

Brockhill Country Park, Sandling

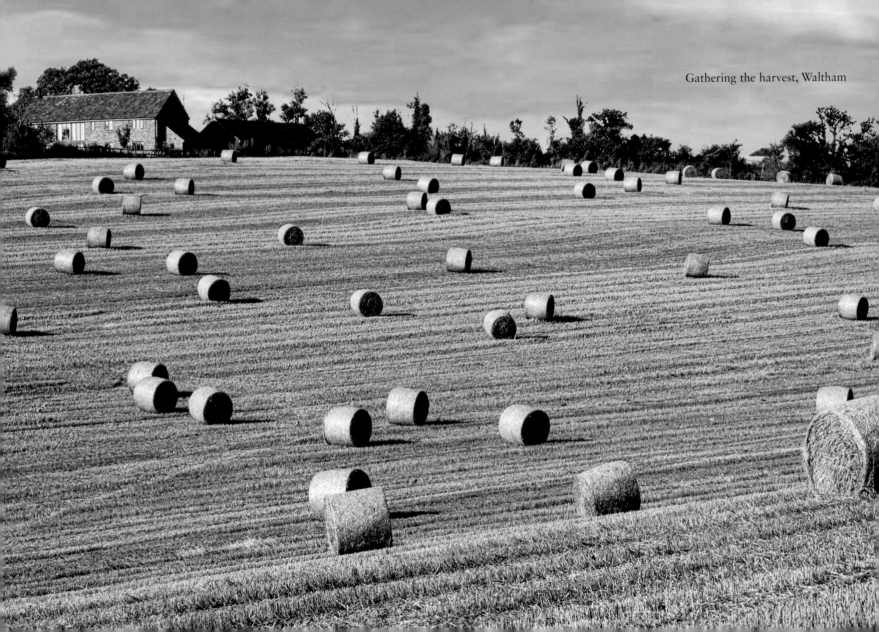

Gathering the harvest, Waltham

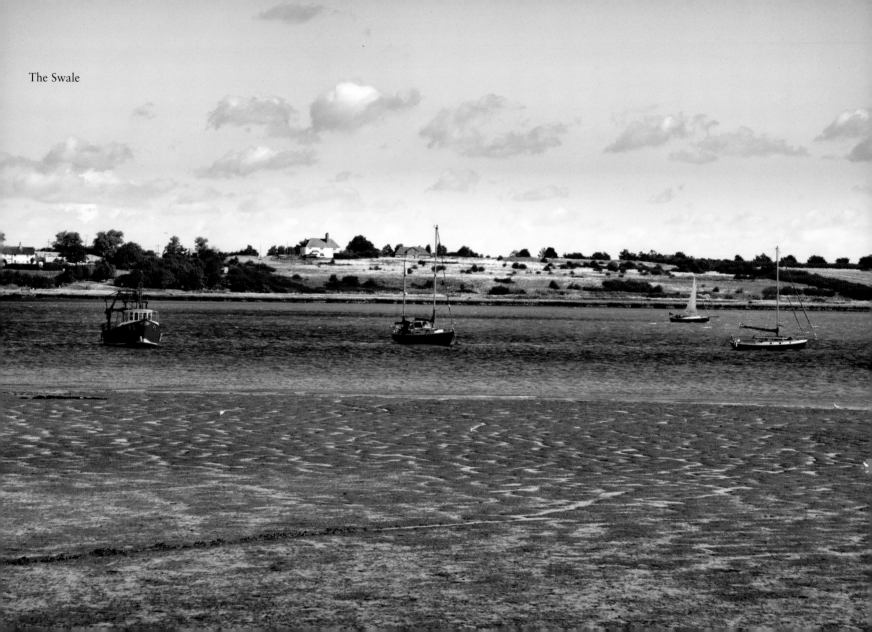

The Swale

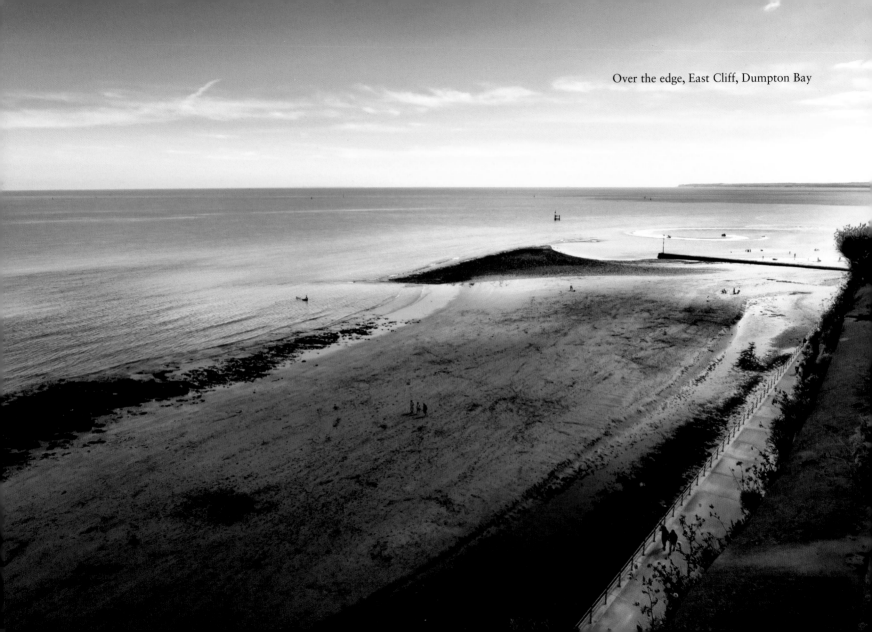

Over the edge, East Cliff, Dumpton Bay

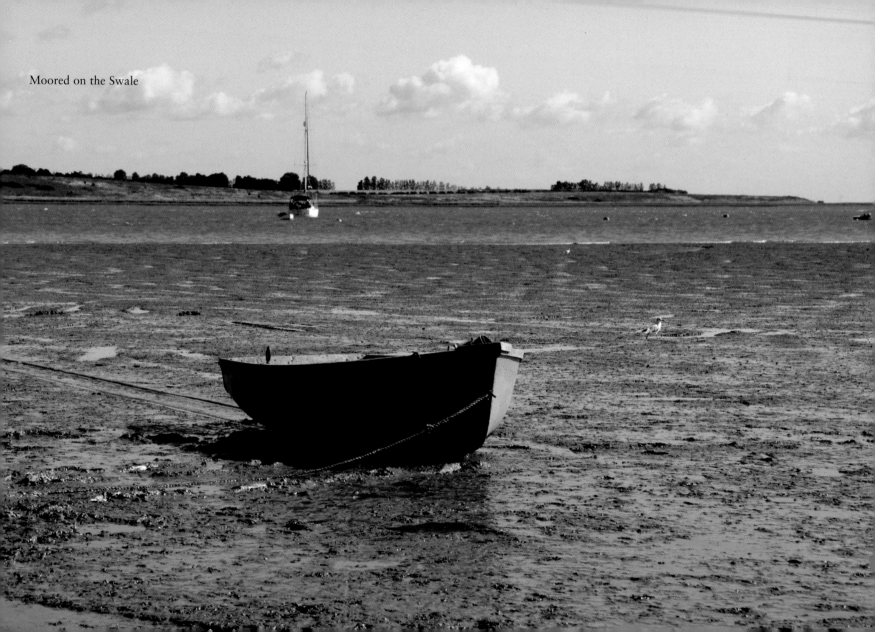

Moored on the Swale

Autumn gold, Mote Park,
Maidstone

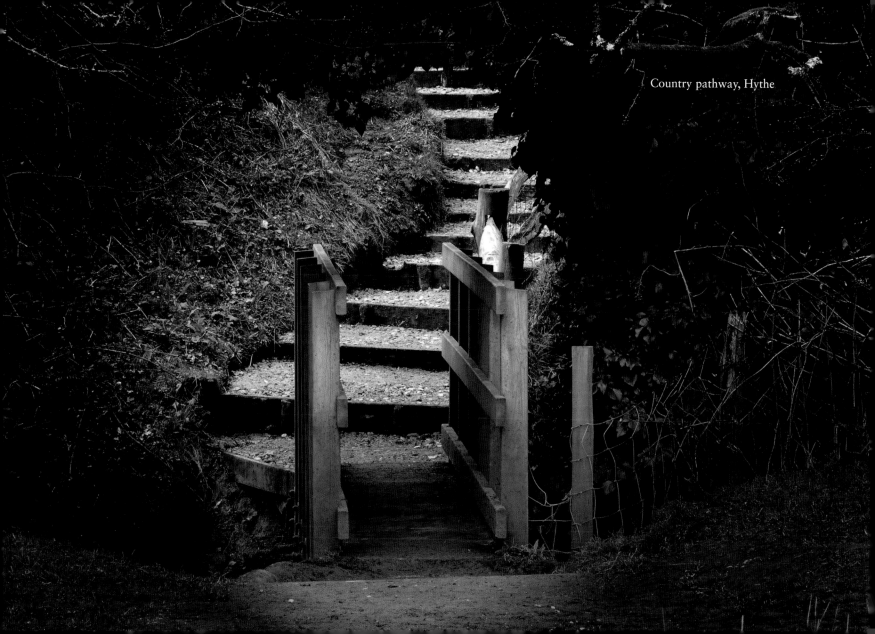

Country pathway, Hythe

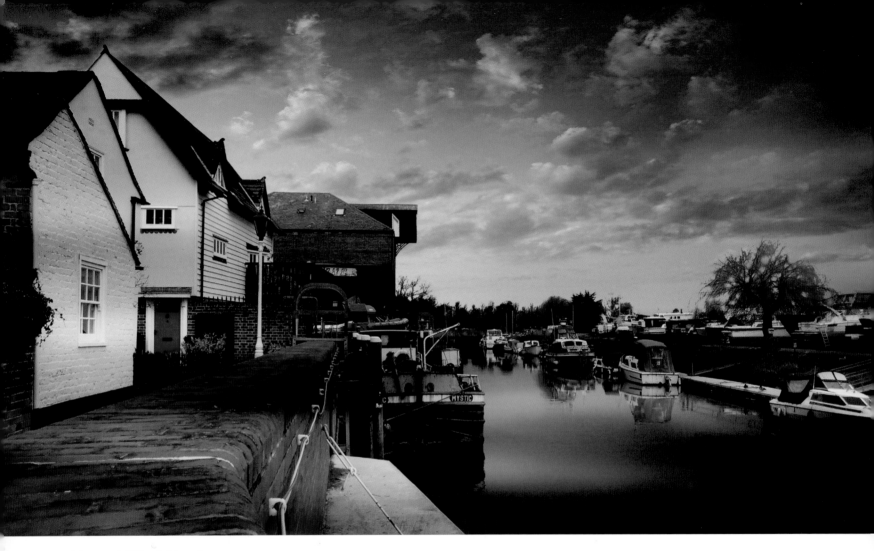

Fisherman's Wharf, River Stour

Eurotunnel, Newington, Folkestone

Sunset over Elham